VOLUME 1

ε-project

A book about the most creative web sites around the world.

E-Project

2002©Pao & Paws
Long Sea International Book Co.,Ltd.

First published and distributed in Taiwan in 2002 by
Long Sea International Book Co.,Ltd.
1/F No.204 Si Wei Road Taipei Taiwan .
Fax.886-2 2706-6109

First published in 2002 by HBI, an imprint of HarperCollins Publishers
10 East 53rd Street
New York, NY 10022 5299
United States of America

Distributed to the trade and art markets in North America by
North Light Books,
an imprint of F & W Publications, Inc.
4700 East Galbraith Road
Cincinnati, OH 45236
Tel. (800) 289-0963

Distributed throughout the rest of the world, excluding Taiwan, by
HarperCollins International
10 East 53rd Street
New York, NY 10022 5299
Fax. (212) 207-7654

ISBN 0-06-008764-1

2002 © HBI

Printed in Hong Kong

ε-project

www.skim.com 265

www.04.jp.org 001

www.deformat.de 113

www.10pm.org 005

www.stampete.de 277

www.2-nd.com 009

www.antirom.com 033

www.acg.media.mit.edu 013

www.deconcept.com 105

www.ae-pro.com 037 www.factory512.com 153

www.k10k.net 173

www.droogdesign.nl 141

www.theapt.com 289

http://d3d2.com 091

www.merzhase.de 201

http://code-design.com 079

www.plasticbag.de 237

www.comfortaction.com 087

www.method.com 205

www.mtv2.co.uk 209

www.statedesign.com 273

http://surface

www.freitag.ch 169

www.axis-media.com 053

www.biganimal.co.uk 065

www.bam-b.com 059

www.potatoland.org 241

www.koneisto.com 185

www.soda.co.uk 269

www.dandad.org/gettyonebloodbank 097

www.flipflopflyin.com 157

www.alambic.qc.ca/nuworld 227

www.neeneenee.de 213

www.norm.to 223

www.shif.jp.org 261

www.designgrphik.com 117

www.onedotzero.com 233

www.keicon.com 181

www.presstube.com 253

Contents

So how do you judge
web site design?

Larry Lock

A designer's personal site will look sharper than the site of a multinational ad agency. An ad agency's site will spark more than a corporate site. A corporate site may seem nicer than e-commerce site. An e-commerce is a site better than a search engine…

Some people would say, it all depends on objectives. Others might propose a matrix of scores giving different weightings to user interface, content, site architecture, interactivity and design.

Then, there is the "wow" factor, the "ah ha" ingredient and the "wish I'd done that" reaction. The authors of *e-project* took a different approach in how to evaluate work. If a site makes you say, "Wish I'd done that!" then it made the book. The sites featured stand out because they have The "ah ha!" ingredient and the "wow" factor.

wow ah ha wish I'd done that

Whether you see the Internet as a medium, or a channel, The overriding common factor of all sites is that it has to appealing. Without that the user will go no further than the home page. We tell our clients that an uninteresting site is like all those shops you pass on the way to work, but still haven't really noticed.

Ever been back to a terrible site on the hope that maybe they'd fixed it? Er…yeah, we didn't think so. It's the old adage, you never get a second chance to make a first impression. The pioneers we spoke to all have every confidence in the Internet. The crash has not diminished their vision of what it can be.

Actually, we're all presidents of the World Wide Web. Because there is an overabundance of business models that have flopped versus those that have succeeded, it pretty much makes everyone in the Interactive and digital agency arena a pioneer. Chasing for market share with a mouse. Some of these sites have won awards. Some of them haven't.

Someone told me the other day that the web had lost its "wow" factor. We couldn't disagree more. One billion emails are sent everyday. That's pretty "wow".

There is plenty of "wow" out there. It's just that companies have filled the web with so much junk that it's so much harder to find the right stuff. And it's our guess that the "wowest" has yet to be seen.

Stand by for *e-project volume 2.*

"Don't give them what they want, give them
 something that they never believed was possible."

– Orson Wells

April Rapier

Roland Young

Mark Fenske

Michael Prieve

John C. Jay

Dan Widen

Susan Hoffman

Tomato

Art Center

RISD

Dad

Mom

Aladdin

Ivee

Acknowledgments

Special thanks to April Rapier for insisting I leave Houston, to Roland Young and Mark Fenske for believing in me; to Michael Prieve, John Jay, Dan Widen, and Susan Hoffman for giving me a chance to work with the best; to Art Center and RISD for precious learning; to all my friends and everyone who has helped me along the way; to Aladdin for opening my eyes to the Internet. To everyone who contributed to the e-project book; this would not be possible without you. To my parents for letting me follow my own path.

To the most giving person, my life time partner, Ivee, for a second chance in life.

Pao 2002 Taipei

www.04.jp.org

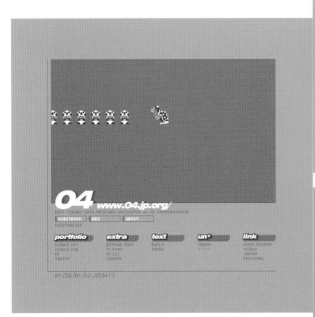

Q1.
What is it about this site (04.jp.org) that makes it different from others?

In a process of development now, and will be drastically changed.

I'm still trying to seek how it can become better.

Q2.
What made you come up with this approach? Inspiration?

In each case, my interest or sense brought me to this result.

Q3.
If you were president of the World Wide Web what changes would you make?

Unify all browsers.

Q4.
What is your best digital idea or project to date?

My video games.

Q5.
Tell us about yourself: age, nationality, interests, anything that makes you different?

My interests are watching and creating all of design products, such as video games, web sites and editorial stuff.

Q6.
List of your favorite web sites and why.

My favorite sites are in this page. www.04.jp.org/link/

Q7.
What's wrong with most web sites?

For making good sites stand out.

www.10pm.org

Q1.
**What is it about this
site (10pm.org) that makes
it different from others?**

We don't try to achieve
anything in particular, other
than our own enjoyment.

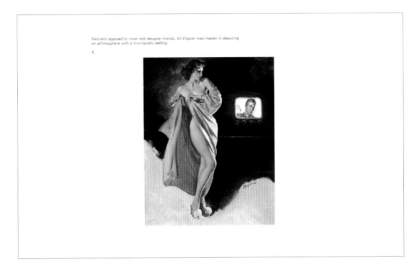

About them:

Awards
3d floor above the galleries; "my member is
the key" award in 2000 delivered by UNESCO.

**Q2.
What made you come up with this
approach? Inspiration?**

Our natural laziness and disorganization, plus
no time at all to try to think about a concept.
Cuban cigars.

**Q3.
If you were president of the
World Wide Web what changes
would you make?**

Change tie.

Q4.
**What is your best digital idea or project
to date?**

We want to digitize the entire world.

Q5.
**Tell us about yourself: age, nationality,
interests; anything that makes you different?**

33 + 30 + 29 + 26
Belgium + Belgie + Belgique + Belgian
Sounds & laughter + Michael Caine + TAN and 3D
rendering + Roast Fish, Collie Weed & Corn Bread.

Q6.
List of your favorite web sites and why.

www.5am.org

Q7.
What's wrong with most web sites?

Nothing is wrong.

www.2-nd.com

2.ND REC THE SECOND. USE IT OR BE IT. ENGLISH DEUTSCH

A second of time is defined as x oscillations of a cesium atom's resonant frequency, and is commonly measured in atomic clocks. If an atomic clock is propelled at near the speed of light (or at any speed), wouldn't that definition of a second be distorted? If so, shouldn't we add a longitude and latitude to the definition since all places on earth travel at different speeds?

A second of time can only be defined relative to the observer. Whether you determine the passage of one second of time with a stopwatch or a Cesium 133 atom, you want the source of that measurement to be in your own inertial frame. What you are measuring is the passage of LOCAL time. There is no universal inertial frame of reference that can determine an "absolute" second to correct for.

Introducing 2.nd rec
2.nd rec was founded in winter 2000 by Johannes Schardt (Berlin) and Christophe Stoll (Hamburg) as an affiliate to the independent record label "fiction friction record co." While fiction friction places emphasis on guitar-based music 2.nd rec will focus on experimental (electronic) music and its various outlets. The debut release exemplifies the label's collaborative ethic - the Italian post rock band "Giardini di Miro" (fiction friction) meets Australian post techno sound artist "Pimmon" on a split-10". The decision for a shared release was not just a friendly or pragmatic one, but is a direct result of an avid exchange of audio material between the artists throughout the creative process, adding to each other's music respectively.

We clearly mean the label to act as a global network, steadily accumulating new artists and collaborators to spread and represent the "virus 2.nd rec".

Vision and platform
2.nd rec is not just a record label - it stands for an ambitious platform and vision. We don't place emphasis on "classic" or "conventional" sound media such as vinyl records or CDs, but actively encourage progressive developments in interdisciplinary, independent and platform-encompassing media. We believe in collaborations between different disciplines, from (electronic) music to visual arts and design as well as the creative usage of code and programming languages.

We regard interactive or generative applications, possibly the result of a collaboration between musicians, designers and programmers, as equally important to 2.nd rec as regular, catalogued label releases like 7" singles, 10" Eps, 12" Eps, 12" Lps, mp3-only, audio/video/web- or Tv-clips, rich media cdrs..

Critique and fighting spirit
2.nd rec is therefore not only pan-medial in approach, but also format-dissolving in the music industry context due to worldwide networks; this is in direct contrast to the music industry as we know it which often enough mentions "defined formats with distinctive local, trend-oriented and commercial framework and goals". Marketing-focused and frighteningly strategic, potential buyers and the reclaimed "target audience" are systematically confused and moulded into a stereotypical framework by the seemingly open, varied release culture of long players (on cd and vinyl), the odd single taken from them, maybe a video clip or cd-rom, the merchandising, the routine promotion rigmarole of press, interviews, live performances..

2.ND REC RESPECT LINKS PAGE CREATED AND MAINTAINED BY SILVER--SILK. (WWW.SAYIMSORRY.DE)

//2.nd related

p i m m o n
australian soundartist pimmon aka paul gough uses a personal computer in combination with two old analogue synths. he also released stuff on **fällt**, **radiantslab**, **static caravan**, **meme**, **fat cat**, **tigerbeat6**, **kraak** and **fals.ch**.

giardini di miro
GdM released on homesleep, fiction.friction and zum records so far. 2.nd released a remix of their song 'dancemania' done by pimmon. it is called 'post DM' and can be found on the 'Giardini di Miro vs. Pimmon 10"ep' (001).

// artists

Autechre
all-time faves and heros forever! this is a new site done by two swedish and one hungarian guy. its very informative and detailed. a brilliant tribute to sean booth and rob brown! (official site can be found via warp records)

boards of canada
loads of inspirations and influences come from this preppy scottish duo..

bogdan raczynski
crazy teen from UK, now living in montreal/CAN. go check out this impressive site and become his friend!

dat politics
three french people from lille doing a mixture between minimalism, electro-pop-acoustic & deconstructed techno.

lexaunculpt
powerbook-generation galore! one of my most amazing discoveries last year! young and very talented. check out the astonishing flash and sound-pieces on his site ...and you will know him by the trail of dead! ;)

jake mandell
former student of biochemistry (3D modelling of protein structure..), now doing an intelligent mixture between club music and academic bleeps and clicks.

jim o'rourke
a man and his frog-pet.'women of the world take over..'

001 001 2.nd rec We don't wanna waste your time. We want you for some precious moments.

NEWS:
Check out the archived stream (5 hours) from the native.lab event, featuring audio-acrobatics by ntrd vs. Vger, Richard Devine, Jake Mandell, Smygljssna, Lazyfish and visuals by Fork Unstable Media. We also have an mp3-excerpt (6.5 mb) from the ntrd vs. Vger-session for you.

New to 2.nd rec: depart++zanshin - two super talented guys from austria. We're proud to announce our first onlinerelease: It is an interactive audio-visual piece; depart did the visual part, zanshin the audio and we love it. Enjoy it in our catalog section!

Read the 2.nd rec info here!

NEWSLETTER:
2.nd rec newsletter
Please subscribe to stay informed.

LISTEN:
Pimmon:
post DM (Giardini di Miro "Dancemania"-Rmx) [mp3]

errorEncountered:
'ohep (boot error)', version 1.1 [prerelease mp3]
'akkola (run error)', version 0.1 [prerelease mp3]

CATALOG:
001: Giardini di Miro vs. Pimmon - 10"ep
002: ntrd. love me. (+ endekks remix) - Mp3 - Very soon!
003: depart++zanshin : sumting (impressure04) - iaAV

Please click on the release titles for further details.

ARTISTS:
Pimmon, GdM, Nitrada, endekks, zanshin, depart

ORDER:
Please send us an email: orders@2-nd.com

... or buy our releases here:
Germany: hardwar, normal, a-musik
Austria: m.dos
UK: normanrecords, chunkyrecords, roughtrade, Boa Melody Bar
Italy: homesleep
Switzerland: namskeio
Benelux: (kraak)3
USA: inzound.com
Australia: synaesthesia

If you are a distributor, mailorder or store and would like to sell 2.nd rec releases, please feel free to contact us!

Introducing 2.nd rec

2.nd rec. The second: use it or be it.

2.nd rec was founded in winter 2000 by Johannes Schardt (Berlin) and Christophe Stoll (Hamburg) as an affiliate to the independent record label "fiction friction record co." While fiction friction places emphasis on guitar-based music 2.nd rec will focus on experimental (electronic) music and its various outlets.

The debut release exemplifies the label's collaborative ethic — the Italian post rock band "Giardini di Miro" (fiction friction) meets Australian post-techno sound artist "Pimmon" on a split-10. The decision for a shared release was not a friendly or pragmatic one, but is a direct result of an avid exchange of audio material between the artists throughout the creative process, adding to each other's music respectively.

We clearly mean the label to act as a global network, steadily accumulating new artists and collaborators to spread and represent the "virus 2.nd rec."

Vision and platform

2.nd rec is not just a record label — it stands for an ambitious platform and vision. We don't place emphasis on "classic" or "conventional" sound media such as vinyl records or CDs, but actively encourage progressive developments in interdisciplinary, independent and platform-encompassing media. We believe in collaborations between different disciplines, from (electronic) music to visual arts and design as well as the creative usage of code and programming languages.

We regard interactive or generative applications, possibly the result of a collaboration between musicians, designers and programmers, as equally important to 2.nd rec as regular, catalogued label releases like 7" singles, 10" EPs, 12" EPs, 12" LPs, mp3-only, audio/video/web or TV-Clips, rich media CD-Rs...

Critique and fighting spirit

2.nd rec is therefore not only pan-media in approach, but also format dissolving in the music industry context due to worldwide networks; this is in direct contrast to the music industry as we know it, which often enough mentions "defined formats" with distinctive local, trend-oriented and commercial framework and goals. Marketing-focused and frighteningly strategic, potential buyers and the reclaimed target audience are systematically confused and moulded into a stereotypical framework by the seemingly open, varied release culture of long players (on CD and vinyl), the odd single taken from them, maybe a video clip or CD-ROM, the merchandising, the routine promotion rigmarole of press, interviews, live performances…

In addition there exists, we think, a strict division between "active" and "passive," meaning the "executing artist's authority" on the one hand and the "quiet and sedated consumer" on the other. This creates a environment in which the important and valuable listener (user) doesn't ever get the chance to look in on the creation of what they're supposed to like and spend their money on, due to a lack of creative and interactive inclusion in the process of "musical communication."

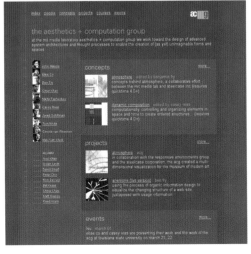

No lone rangerism

With the reassuring knowledge that our views have become more widely accepted and a lot of respect for others with similar approaches, 2.nd rec attempts to distance itself from this automated and passion-free role-playing. We don't simply wish to "fuck the system," but aim to kick off change by actively offering ideas, starting points and concepts for alternative solutions, maybe via new or re-developed, possibly transitory formats. This will apply to the actual release formats, but also and mostly to the environment that shapes the daily work and responsibility of a record label.

Vision vs. utopia

For us this approach has become paramount because we know that too many live in the false hope and illusion that "everything will be ok"—there are reliable controlling and guiding institutions whose aim it is to preserve the rights to mental property with a keen feel for new developments, adjusting to these developments and creating a framework that is acceptable and just for all sides and based on "prevailing guidelines."

We sense and feel that not enough is actually happening, that too few groundbreaking and boundary-crossing templates for a future music industry and popular culture are being developed, shouted about or implemented while yesterday's soup is happily reheated over and over again.

www.acg.media.mit.edu

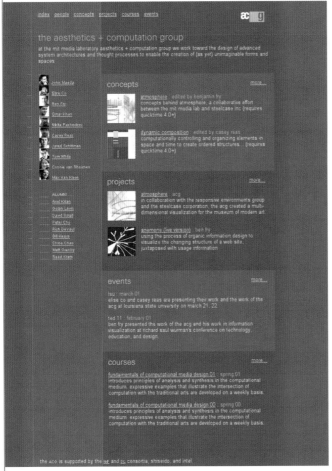

Q1.
What is it about this site (acg.media.mit.edu) that makes it different from others?

I try to make my site both interesting to view and also interesting to interact with.

Q2.
What made you come up with this approach? Inspiration?

My approach is based on the idea that, minimally, when one visits a web site, there should be something worth interacting with. Actually, my site is just a sketchbook of ideas-in-progress, but I only try to post the sketches that I find tolerable.

Q3.
If you were president of the World Wide Web what changes would you make?

This question is antithetical to the idea of the World Wide Web, which is inherently decentralized and has no governance.

However, given some power to change the course of things, I would eliminate Flash entirely.

John Maeda is Associate Director of the MIT Media Laboratory where he is also Sony Career Development Professor of Media Arts and Sciences, Associate Professor of Design and Computation, and Director of the Aesthetics & Computation Group (ACG).

His mission is to foster the growth of what he calls "humanist technologists" -- people that are capable of articulating future culture through informed understanding of the technologies they use. The ACG is an experimental research studio that was founded in 1996 as the successor to the late Professor Muriel Cooper's Visible Language Workshop. In the short time since its existence, individual experimental work in the ACG has received numerous awards and acclaim for a uniqueness in both concept and craft. A major component of the ACG's efforts involves outreach to the design and art community in the form of workshop and events that introduce the underlying concepts of computing technology, as exemplified in the ongoing Design By Numbers project. A 480-page retrospective of Maeda's personal work entitled "MAEDA@MEDIA" is forthcoming October 2000 from Thames & Hudson in Europe, and Rizzoli in the US. A collection of work by Maeda is visible at http://www.maedastudio.com

[more...]

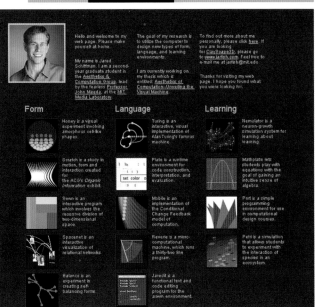

Q4.
**What is your best digital idea or project
to date?**

This is really for others to decide.

Q5.
**Tell us about yourself: age, nationality, interests;
anything that makes you different?**

I'm 28 and American.

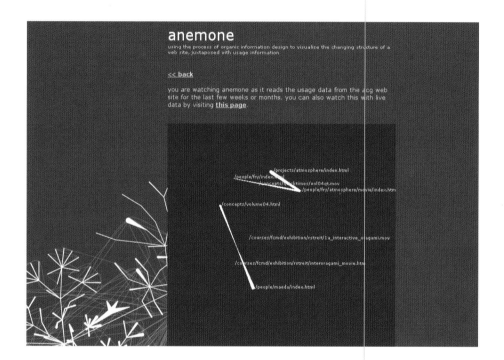

anemone

using the process of organic information design to visualize the changing structure of a
web site, juxtaposed with usage information

<< back

you are watching anemone as it reads the usage data from the acg web
site for the last few weeks or months. you can also watch this with live
data by visiting **this page**.

/projects/atmosphere/index.html
/people/fry/index.html
/concepts/clocktimes/vol04qt.mov
/people/fry/atmosphere/movie/index.htm
/concepts/volume04.html
/courses/fcmd/exhibition/rstreit/1a_interactive_origami.mov
/courses/fcmd/exhibition/rstreit/interorigami_movie.htm
/people/maeda/index.html

Q6.
List of your favorite web sites and why.

www.sgi.com/grafica/
Paul Haeberli has more ideas in one month
than most people will have in a lifetime.

www.evolutionzone.com
Amoeba is an admired friend and peer. I love
the way he combines diary, observations, and
a ton of strong work into his site.

www.sodaplay.com
Soda knows from computational design.
Few do.

Q7.
What's wrong with most web sites?

The answer to your question is contained within it. In statistics, the "law of averages" states that the greatest bulk of any given population of samples will be average, and that there will be an extremely tiny number of samples which are truly exceptional. If "most web sites" refers to the 90% of web sites below the 90th percentile of quality, then that's the 90% of people who didn't have the time, energy, willpower, desire, interest, rigor or ability to make anything worth looking at. The more interesting question is, what makes a given site outstanding? And the answer is always: some unique viewpoint and a lot of sweat.

www.aeriform.co.uk

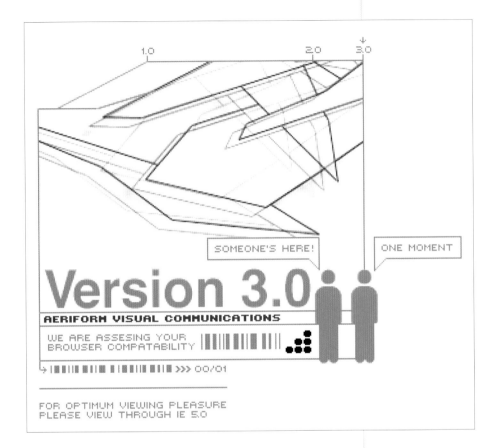

Q1.
**What is it about this site (aeriform.co.uk) that makes it different
from others?**

The main feature that makes Aeriform stand out is the long horizontal scroll. Although
this had been done before, it was still quite a new approach when it launched.

Q2.
What made you come up with this approach? Inspiration?

The idea of one long piece of artwork for each page appealed to me. This also serves as an
opportunity to show my styles of working.

Q3.
If you were president of the World Wide Web what changes would you make?

I would close the whole thing down until people had learnt to limit their use of Flash.

Q4.
What is your best digital idea or project to date?

Aside from Aeriform, I also work for MeCompany where there are always some tasty jobs coming in,
in fact too many to narrow it down.

Q5.
Tell us about yourself: age, nationality, interests; anything that makes you different?

Now at the age of 30, I was born in the UK (North East) and I went straight into graphic design from leaving
school, feeling that going straight into industry was a quicker route to knowledge than university. Nothing
interests me more than sitting down with a healthy machine and being let loose.

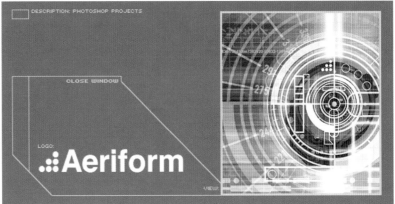

DESCRIPTION: ONE OF TWENTY THREE
ILLUSTRATIONS PRODUCED FOR
ASHRIDGE MANAGEMENT COLLEGE.

CLOSE WINDOW

LOGO:

ASHRIDGE

VIEW:

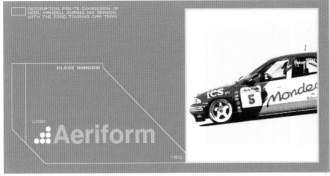

DESCRIPTION: PRIVATE COMMISSION OF
NIGEL MANSELL DURING HIS SEASON
WITH THE FORD TOURING CAR TEAM.

CLOSE WINDOW

LOGO:

Aeriform

VIEW:

DESCRIPTION: IDENTITY & COVER
ILLUSTRATION FOR ON-LINE
MAGAZINE, ARMCHAIR HERO.

CLOSE WINDOW

LOGO:

VIEW:

Q6.
List of your favorite web sites and why.

www.warprecords.com
For keeping up to date on the music scene and maxing out my credit cards.

www.k10k.net
For keeping up to date on the design scene.

www.linkdup.com
It's the start point to any session on-line.

Q7.
What's wrong with most web sites?

I wouldn't say there is anything wrong with most web sites. At the end of the day,
everyone is busting out their own style and different styles appeal to different people.
I do think that the scene may be a little stale right now, but every now and then,
something will come along that completely restores your faith in the web.

About them:

Aeriform is a shifting operation, never settling in one place. It's run on a part-time basis by Sean Rodwell and assisted by Angela Carter.

www.am-it.de

Q1.
What is it about this site (am-it.de) that makes it different from others?

[Andreas Mayer] it's gray.

Q2.
What made you come up with this approach? Inspiration?

[Andreas Mayer] we wanted to keep it as simple as possible (this time) but state-of-the-art at the same time.

Q3.
If you were president of the World Wide Web what changes would you make?

[Andreas Mayer] I would permit different kinds of browsers, one internet, one browser.

Q4.
What is your best digital idea or project to date?

[Andreas Mayer] ?

Q5.
Tell us about yourself: age, nationality, interests; anything that makes you different?

[Andreas Mayer] I'm 27, German, interested in computers, movies, sci-fi, technology, nature, lakes, love to take pictures of summer skies in the evening through the window of my living room, and I rather decide wrong than not at all.

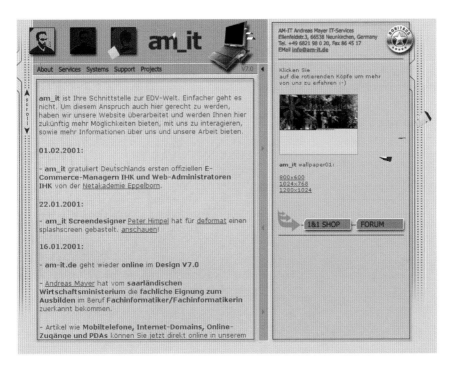

Q6.
List of your favorite web sites and why.

[Andreas Mayer] www.atelier. Because it's one hell of a club and the afghan whigs played there when they were on their last Europe tour and I fucking missed it and have never ever been there and all I know about it is what my friends told me and what I got from their site. www.h2g2.com. cause it's a cool idea of a cool person.

Q7.
What's wrong with most web sites?

[Andreas Mayer] you don't see the important stuff at the first moment and have to search where to click to get to the stuff you want.

About them:

[Andreas Mayer] our headquarter is located in Neunkirchen, Germany. At the moment my team consists of my graphics designer Peter Himpel (www.stampete.de), a computer technician, myself and several freelancers who participate in projects when required.

profil 03

am_it betreut unternehmen und privatpersonen, sowie öffentliche einrichtungen in allen belangen der edv und telekommunikation.
dabei geht es uns darum, arbeitsabläufe edv-gestützt zu verbessern.
dies vereinfacht ihre arbeit, macht sie effizienter und somit kostengünstiger.
was dazu führt, dass ihnen ihre arbeit zum einen mehr spass macht,
zum anderen besser gelingt,
und sie zu allem überfluss am ende noch mehr geld übrig haben,
dass sie dann uns geben können ;-).

> andreas mayer

> peter himpel

> thomas molitor

> marc prams

peter himpel
screen- / webdesign

*08.06.1975

"ja, das soll so sein!"
"ich rauch noch meine zigarette, dann mach ich das."
"ich mach keinen kaffee."

> zurück

thomas molitor
pc-technik / netzwerke

*30.03.1968

"guten morgen!"
"daran kann ich mich gar nicht erinnern"
"ich trink doch keinen kaffee."

> zurück

kontakt 04

name vorname

strasse plz

ort email

fon fax
+49 +49
url betreff
http:// Anfrage
ihre nachricht

Absenden Reset

am_it
andreas mayer it-services

ellenfeldstr. 3
66538 neunkirchen, germany

tel +49 6821 98 0 20
fax +49 6821 86 45 17

elektronische post an:

andreas mayer
peter himpel
thomas molitor
marc prams

www.antirom.com

In February 1995, Antirom was launched at Camerawork Gallery in Bethnal Green, London. The CD-ROM was funded by the Arts Council and consisted of seventy different interactive toys, encouraging the use of multimedia as a forum for drawing together diverse talents and interests, as well as experimenting with new forms of language made possible by non-linear and interactive media.

andyc

andyp

aNt

jason

joe

joel

luke

nik

onion

rob

sophie

tom

Antirom was set up as a limited company in January 1996, in response to an unanticipated demand from both the fine art and the commercial spheres. We installed ourselves in a tiny office in Covent Garden.

In December 1996 Antirom were invited to share
The Tomato Building with Tomato on Lexington
Street in SoHo and have since decided to disperse
as a commercial entity reserving the Antirom for
arts-based work and performances.

everything changes
(one day I'll even change this)

Antirom was awarded a silver pencil from the 1997 British Design and Art Direction awards for its interactive kiosk design on behalf of Levi-Strauss Europe.

Various members of Antirom are frequently invited as writers, speakers, tutors, performers and exhibitors around the world but closed the doors of the collective in 1999.

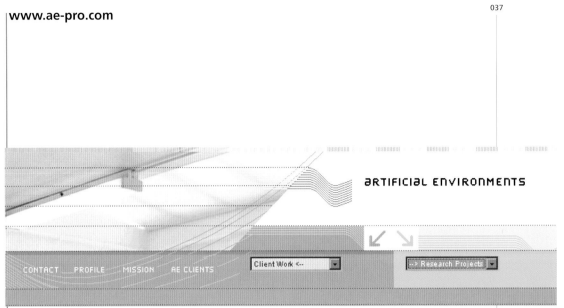

artificial environments

CONTACT PROFILE MISSION AE CLIENTS | Client Work <-- ▼ | | --> Research Projects ▼ |

Q1.
What is it about this site (www.ae-pro.com) that makes it different from others?

Many new media concepts attempt to separate form and function, style and content, thinking this will leave something unadulterated and 'pure.' But it is style and form that make the initial connection with users. These factors, freed from the modernist dogma of separation, should enhance the function and content rather than obfuscate them.

While design is our passion, functionality and usability play an equally important role in our work. I think our site manages to marry these often opposing concepts into a whole. We also bring together two design approaches; emotion and intelligence and again we feel our site is a good example of how these can come together.

Q2.
What made you come up with this approach? Inspiration?

Our inspiration is to contribute to and shape popular culture.

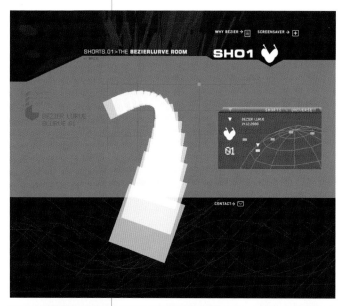

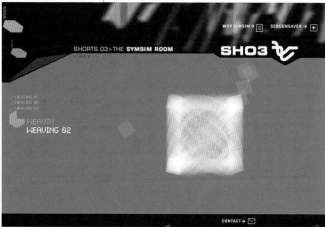

Q3.
If you were president of the World Wide Web what changes would you make?

I would create a committee to oversee browser and technology standards that actually has the power to implement these standards. This would make the web an even more creative medium.

Q4.
What is your best digital idea or project to date?

I think the LOVE project I worked on with DHKY. I did not do too much in the execution part of it, but I provided the idea and spark of wanting to gather Asian talent from around the world and create work based on a four-letter-word theme. I am my own worst critic, so I must say I have no best work, but you can judge for yourself.

AE SHORTS: growing collection of digital experiments within a 3-dimensional universe.
www.ae-pro.com/project.asp?proj=shorts

LONDON COLLEGE OF PRINTING WEB SITE
The on-line college experience for the London College of Printing.
www.lcp.linst.ac.uk/

TRIMO
www.ae-pro.com/project.asp?proj=trimo&kw=
Trimo is an intelligent, teachable, versatile and completely modular creation. A toy over time develops a personality of its own.

A-LIFE
60 sec digital film experiment about artificial life.
(Artificial life is a fascinating science exploring self-organizing systems and making predictions on their behaviors.)
www.ae-pro.com/project.asp?proj=alife&kw=

SPACEBOOK
Visual explorations in 2D space (on paper, ladies and gentlemen!)
www.ae-pro.com/project.asp?proj=spacebook&kw=

CD-ROM for RSA STUDENT DESIGN AWARDS SCHEME
Now in its second year, CD-ROM for the RSA Student Design Awards 2000 features winning work from the best and brightest of the undergraduate design community and is a pleasure in tactile interactivity.
www.ae-pro.com/project.asp?proj=sdacd&kw=

Q5.
Tell us about yourself: age, nationality, interests; anything that makes you different?

29, German, interests — in virtual space, the history of video games, user experience and storytelling/narrative.

32, German, passionate about animation (especially Manga), typography, 3D graphics and the Internet!

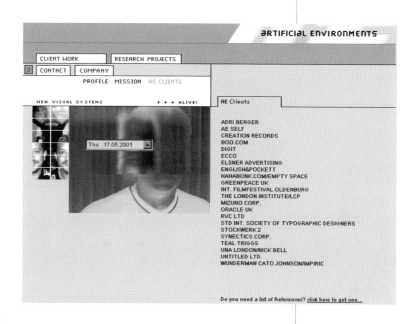

Q6.
List of your favorite web sites and why.

This definitely changes from day to day! Today they are:

www.mapquest.com
The best site to plan a road trip!

www.wired.com
Excellent, usable and boldly designed.

www.google.com
The starting point for any journey.

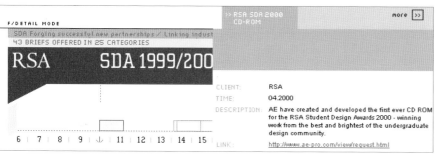

F/DETAIL MODE

HILLA NESKE

Bob&Hoskins is an ultra modern gangster adventure - dark, schizophrenic and ultimately funny!

CLIENT: **Empty Space**
TIME: **2001**
DESCRIPTION: **Animation Series Gangsta Style**
LINK: http://www.e4.com

>> SFA ALBUM

F/DETAIL MODE

PETE FOWLER

Never in the field of model making, have so many exotic chocolates been eaten by one Welshman. We, at Pete Fowler's brain, would like to say RESPECT to AE and SFA.

CLIENT: Creation Records
TIME: 04.1999-07.1999
DESCRIPTION: 4 album/single covers for the boys - weird and welsh

Q7.
What's wrong with most web sites?

They are not thinking about their audience. Most of the obscure specialist sites seem very oddly designed when you first look at them but they usually grab the audience they are intended for immediately. Most web sites don't do that; they don't address you as a person with your individual needs.

About them:

Established in 1998 and based in London, Artificial Environments handle concepts, design and technology for Interactive Media. They deliver original, dynamic services and products to their clients in the UK and across Europe, which include: Greenpeace UK, The London Institute, Oracle UK, the Royal Society for the Encouragement of Arts (RSA), creative management consultants Synectics and Untitled Imagelibrary among others.

In 2000 AE started a research project: AE Shorts, a digital space filled with interactive micro-experiences. AE was invited to speak at the Profile Intermedia Conference in Bremen, and held workshops on interface design and interactivity in places like the London College of Printing or LAU in Beirut. AE received a commendation at the 2001 Design Week awards and are listed in the 2001 D&AD annual. AE key members are Hilla Neske and Tom Elsner.

Hilla Neske: Hilla has a strong design background, having worked with companies such as MetaDesign (in Berlin), Sunbather Ltd (London), and John Barnbrook and Steven Coates (London). Working on a wide range of projects, she has worked with many clients, including Shell, Virgin Interactive, Springer Publishing, as well as Greenpeace Digital.

She is passionate about animation, typography and 3D graphics and, in 1996, was awarded a D&AD Student Award in Interaction Design.

Tom Elsner: Tom has been a designer, animator and programmer for clients such as EMI, Adobe, Universal Music and Eye magazine while working for Westworld Interactive, UNA London/Nick Bell and Digit.

In 1998 he won an RSA award for co-developing Trimo, an interactive toy. As a visiting lecturer in interactive media on the Typo/graphic Studies MA and the Graphic and Media Design BA at the London College of Printing, his interests — in virtual space, the history of video games, user experience and story-telling/narrative — form the basis of his lectures.

www.astrofarm.com

Q1.
What is it about this site (astrofarm.com) that makes it different from others?

I think the site has atmosphere, a certain mood to it, and I hope we have had success in bringing something of a mysterious rhythm into it. We tried to make everything, from the color scheme and graphics to the navigation and feeling, kind of mystic and strange. The trick with the graphics on the site is their placement towards each other. I remember we spent about a month agreeing on where to place the different graphic elements.

Q2.
What made you come up with this approach? Inspiration?

As our company name reflects an idea of a farm, it was important to keep that in mind when putting together the graphics. We tried to look at farms and their surroundings in our area (which is kind of country-like, like barns and silos and stuff, as well as NASA-drawings of futuristic architecture for living on planets like Mars, etc. Also we used untraditional methods for achieving the right feeling to the site. For example, we scanned a leaf, and carefully picked the colors of it for the color scheme.

Q3.
If you were president of the World Wide Web what changes would you make?

I'd start a war with Netscape. (I don't like the browser. Sorry.)

Q4.
What is your best digital idea or project to date?

It is not launched yet, but it is going to be Amnesty Norway when we launch it. It will be great stuff.

Q5.
Tell us about yourself: age, nationality, interests; anything that makes you different?

My name is Joe Vik; I am the art director of Astrofarm.com, now quitting that job to start up a small Oslo-based digital design studio, n-fabrik.com. I am 26 years old, from Oslo, Norway. I have strange friends, a strange (but cute) girlfriend, and like to do strange things.

Hmm, I suffer from something called panic disorder, which makes client contact difficult and sometimes hell, but I manage to cope with it most of the time. It forces me to design and produce at my very best at all times, so I can convince people I'm quality though I might sound strange and shy at a meeting. When I don't do graphics and code, I scuba dive, love movies and music, my family and friends.

Q6.
List of your favorite web sites and why.

Futurefarmers.com, because Amy is dynamic, beautiful and amusing. Fork.de because they are so irreverent and they engage a lot. Posttool.com because they dare.

Q7.
What's wrong with most web sites?

Most web sites are not designed. They are made by people with little or no skills in digital design.

Kode til Visual Cafe

Norges nye pc-blad

Det bladet du holder i hånden er et resultat av måneders hardt arbeide og mange personers kunnskaper og kreativitet. I seg selv er ikke det noen garanti for suksess, men vi er allikevel sikre på at vi har laget et produkt som det er god plass til i det norske markedet. Til tross for ganske høy selvtillit, behøver vi allikevel innspill fra dere som kjøper det første nummeret. Vi vil vite hva dere synes, hva dere vil ha mer av, temaer dere savner, programmene på cd-en, vi ønsker ideer til reportasjer osv. Ingen tilbakemelding er for liten og ingen er for stor.

Har noen lyst til å la meningene sine komme på trykk, er det bare å si ifra. Vi behøver tanker, oppfatninger, ting satt på spissen, provokasjoner, nye løsninger og at noen stiller kritiske spørsmål til den bransjen som skal levere produktene vi skal skrive om. Dette skal vi forsøke å bringe videre slik at leverandørene selv skal få en anledning til å svare. Hva holder de på med egentlig, leverandørene og produsentene?

☐ Velkommen til Einar Aaby A/S

Hjem
Ansatte
Samarbeid
Kontakt
Messer
Windy
Draco
Bruktbåter
Om oss

Einar Aaby A/S er Norges største Windy og Draco Oceancraft forhandler. Selskapet ble etablert i 1983 og har i alle disse årene hatt gleden av å selge Windy som er en av Europas mest anerkjente leverandører av sportscruisere mellom 25 og 50 fot.

Fra 1983 og frem til i dag, har Einar Aaby A/S forretningsfilosofi vært at våre kunder er vårt beste salgsargument. Vi er takknemlige og setter stor pris på våre kunder som i flere år har valgt Windy og Einar Aaby A/S om og om igjen.

Våre samarbeidspartnere er noen av bransjens dyktigste. Dette sikrer at våre kunder får optimal oppfølging på service, reperasjoner og ettermontering av utstyr og lagring.

En Windy bygges for dem som verdsetter gjennomgående kvalitet. En Windy bygges slik at du føler deg så komfortabel på sjøen at du ikke vil være opplevelsen foruten.

Draco Oceancraft, disse populære modellene balanserer praktiske fasiliteter, eksklusiv komfort og en enorm yteevne. Derfor egner båtene seg utmerket til en skjærgårdstur med hele familien ombord. Men du kan også invitere til en uforglemmelig opplevelse av fri fart og sjø i mer krevende farvann.

Einar Aaby A/S ønsker alle velkommen til vår store utstillingshall i Asker hele året. I perioden 1. oktober til 1. mai har vi alle modellene utstilt.

Velkommen ombord!

www.atomicattack.com

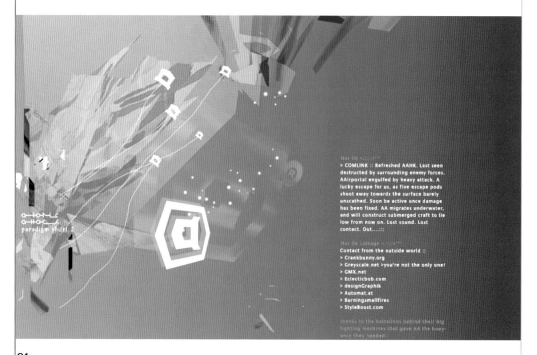

Q1.
What is it about this site (atomicattack.com) that makes it different from others?

I don't see my site as being any different to anyone else, since I did this site from the view of personal experiences and as a form of self-expression, entertainment and helping to expose others in Hong Kong. What I can say is that this site is probably every aspect of myself being thrown in, like I am some flasher on the web. My aim is to use this as a channel to promote Hong Kong's up-and-coming artists, the ones who have the edge. Their struggles and their path towards their goals is clear as crystal. I hope I will be the bridge for them in getting their name out there in the world, PLUS I will have FUN in the process. Hong Kong is a very unique place, people don't mix too much, and keep to themselves often. I will try and break barriers down with my site, as well as with the new magazine that will be on my site, coming soon. I am also a very very shitty writer, so bear with the site.

Q2.
What made you come up with this approach? Inspiration?

It was a natural path that has developed for three years now, in design, music and friends. I find that I always try and do things in complicated ways, but strip it down to simplistic forms. I am a perfectionist to the point where it's doing me damage. My inspirations are from my life, my emotions, and my experiences — love, hate, and more love.

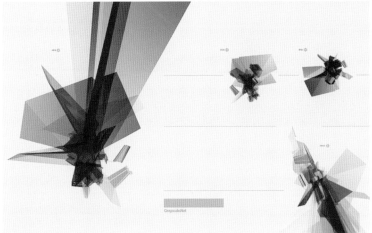

Q3.
If you were president of the World Wide Web what changes would you make?

Censor all the crap that's out there, no, I would keep porn (for the record) as well as exposing the eleven secret herbs and spices that they put on those frozen chickens.

Q4.
Tell us about yourself: age, nationality, interests; anything that makes you different?

Being 30 makes me different especially when it FEELS so lonely as opposed to being in your 20s. I am Hong Kong born, Australian Chinese, I am also a DJ spinning from everything to anything that has feel good jazz and funk licks. I used to have a record shop 'cause I LOVE music. I love eating Mango too, named my turtle Mango as well. I love collecting magazines and books; art, comics; TOYS TOYS TOYS, especially robots, Star Wars and Japanese anime.

Q5.
What's wrong with most web sites?

By being web sites in the first place and nothing else.

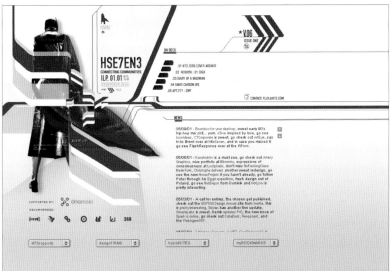

www.axis-media.com

Q1.
What is it about this site (axis-media.com) that makes it different from others?

The navigation & music are probably the most unique aspects. We were nominated for the experimental & navigation categories at an international flash film festival. We wanted to create an on-line environment that would draw the visitor in.

Q2.
What made you come up with this approach? Inspiration?

We wanted to think outside of the box and communicate that you can harness this incredible technology and marry it with classic art. So many sites out there are cool BUT very high-tech in design & music. We wanted to express the other extreme so that our clients could realize anything in between was possible.

Q3.
If you were president of the World Wide Web what changes would you make?

Outlaw HTML.

Q4.
What is your best digital idea or project to date?

Our site is definitely the most creatively edgy. But since completing it we have had many requests for this level of design & programming. So, some pretty exciting projects are in the works. Stay tuned!

Q5.
Tell us about yourself: age, nationality, interests; anything that makes you different?

Our team (depending on the project) is made up of seven guys and one girl, aged 17 – 36. All of us (with the exception of one American!) are Canadian.

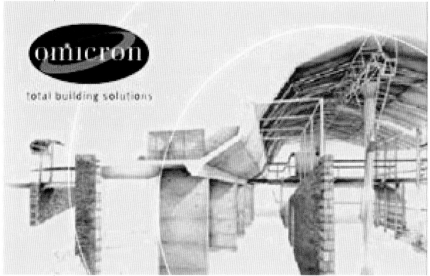

contact *inspire*

info@axis-media.com

tel 604.888.AXIS (2947)
fax 604.888.7184

Vancouver, BC, Canada

AXIS

v	x	y
0.0	141	253

philosophy *evoke*

Axis Interactive Design Inc. offers strategic marketing design for print,
Internet & multimedia. Our studio works with each client from concept to
completion, creating a full range of integrated marketing solutions.

As our name describes, we are actively searching out better ways help our
clients deliver their message in an interactive way. The Internet is today's tool
for sharing information, selling products and expanding your global presence.
Axis will work with you to establish your company on the Web, through site
architecture & design, shockwave, database integration and e-commerce.

e-mail us

AXIS

v	x	y
0.0	455	209

About them:

Axis Interactive Design Inc. was established in 1996 and offers a combined twenty-five years of experience in the new media industry. We are well positioned to provide the latest in technology and communication techniques with efficiency and quality.

As our name describes, we are actively searching out better ways to help our clients deliver their message in an interactive way. The Internet is today's tool for sharing information, selling products and expanding your global presence. Our goal is to establish our clients on the Web, through site architecture & design, database integration, e-commerce and Flash.

Key members
David Ediger, Principal & Creative Director
Amber Hark, Project Manager & Muse
Robert Penner, Flash Alchemist for the Axis Site

Awards
Mohawk Award of Excellence
Potlatch Award of Excellence
Two-time finalist Flash Forward 2001, Flash Film Festival, San Francisco

www.bam-b.com

Q1.
What is it about this site (bam-b.com) that makes it different from others?

It is purely visual.

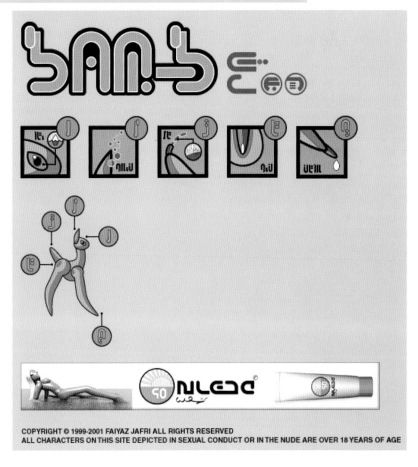

Q2.
What made you come up with this
approach? Inspiration?

I needed an exhibition space for my art.

Q3.
List of your favorite web sites and why.

Dublab.com, great music. Eboy, great pixel esthetics.
Netbaby, great pixel esthetics. Leegte.org, pure web art.

Q4.
What's wrong with most web sites?

Most of them are too conventional and just plain boring.

totem gallery and UNIT inc. cordially invite you to the
opening reception of

POOL
faiyaz jafri
an exhibition of contemporary digital art

opening reception thursday march 8, 2001 from 6-9 pm
exhibition dates march 8 - april 8, 2001

smartwater

Bombay Sapphire
special thanks to the color wheel inc.

totem gallery
83 grand street (bet. wooster & greene street) 212 925 5506
www.totemdesign.com

MOTHERSHIP a mobile exhibition
in collaboration with the color wheel inc. Faiyaz Jafri exhibits his art piece Mothership
march 5 to april 5, 2001
on the Colorwheel delivery truck driving around New York and the five burroughs

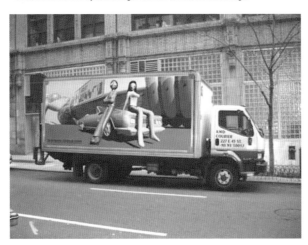

About them:

Faiyaz Jafri is a New York-based digital artist. Originally of Pakistani descent, he was born and raised in the Netherlands. Upon graduating from Delft University with a Masters degree in Industrial Design Engineering in 1996, he moved to Amsterdam to pursue a career in computer art. Faiyaz then moved to New York in 1998.

Highly inspired by Japanese comics and animation, he specializes in the medium of computer generated art and design. His art features original 2D and 3D digital characters, which are solely computer generated. Faiyaz explores how innocence and eroticism are contradictory and yet closely related themes. He expresses these ideas through his work as a freelance illustrator, his art pieces and his animations.

Faiyaz Jafri has held solo shows of his digital work, in the form of giant wallpaper installations and large billboards on the streets of Amsterdam and New York. He has also directed short animation videos, which have been screened at festivals and shown on the Internet.

The web works as a powerful exhibition space for his work. Faiyaz hosts his own web site gallery space (www.bam-b.com). His web site has been reviewed and voted best site by many web magazines around the world. A Faiyaz piece, Nova Sega, was created by The Bronwyn Keenan Gallery for their gallery on the web.

His work has also been published in books, such as *Fluid*, by Faiyaz Jafri, and *Symbol Soup*, by André Plateel. Faiyaz Jafri contributes to magazines, which include *The Face* (UK), *Nova* (UK), *Wired* (US), *Spin* (US), *Raygun* (US), *Numéro* (France) and *Jalouse* (USA).

Awards
Solo Projects
2001, Mothership, billboard, New York
2000, Consume & Die, exhibition, Mazzo, Amsterdam
1999, Nova Sega, web project, Bronwyn Keenan gallery, New York
1999, *Fluid*, art book, Amsterdam
1998, Alien Propagation, web project, New York
1997, Mazzo, mural, Amsterdam
1995, Nightown, exhibition, Rotterdam
1994, Arena, exhibition, Amsterdam
1994, Mazzo, mural, Amsterdam
1994, Stalker, exhibition, Haarlem

Group Projects
2001, Pictoplasma, group web exhibition (www.pictoplasma.com)
2000, Project 001, group web exhibition
1997, Mind the Gap, video projection, Amsterdam

Medium
All of the artwork by Faiyaz Jafri is digitally generated.

www.biganimal.co.uk

Q1.
What is it about this site (biganimal.co.uk) that makes it different from others?

Pure fun and magic purple people station.

Q2.
What made you come up with this approach? Inspiration?

Inspired by other genius magic from around the globe — old and new — Scooby doo.

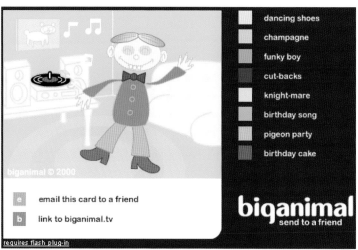

Q3.
If you were president of the World Wide Web what changes would you make?

Free ADSL for everyone in the world!

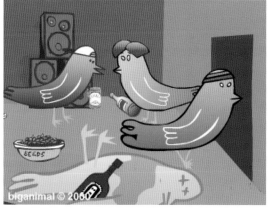

Q4.
What is your best digital idea or project to date?

Design for www.oasis-stores.com — best work is yet to come.

Q5.
Tell us about yourself: age, nationality, interests; anything that makes you different?

20s (only just), British (only just) bottom line is not money — quality — new ideas — making work that surprises and thrills.

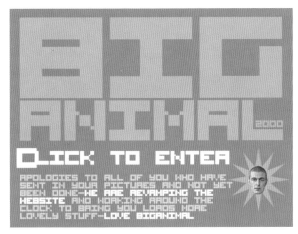

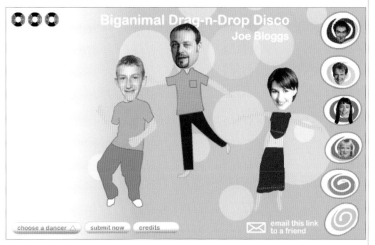

Q6.
List of your favorite web sites and why.

www.bullseyeart.com
Genius in motion.

www.eboy.com
Coolness.

www.jotto.com
Lovely drawings.

Q7.
What's wrong with most web sites?

Dull. Dull. Dull.

www.blind.com

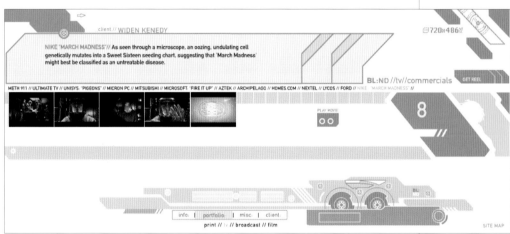

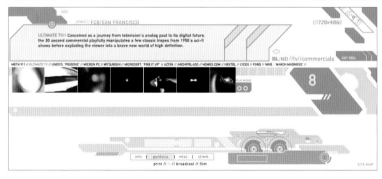

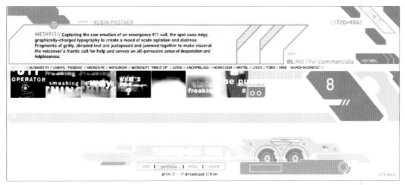

client / RUBIN POSTAER

METH911// Capturing the raw emotion of an emergency 911 call, the spot uses edgy, graphically-charged typography to create a mood of acute agitation and distress. Fragments of gritty, abraded text are juxtaposed and jammed together to make visceral the voiceover's frantic call for help and convey an all-pervasive sense of desperation and helplessness.

BL:ND //tv//commercials

// ULTIMATE TV // UNISYS "PIGEONS" // MICRON PC // MITSUBISHI // MICROSOFT "FIRE IT UP" // AZTEK // ARCHIPELAGO // HOMES.COM // NEXTEL // LYCOS // FORD // NIKE "MARCH MADNESS" //

info | portfolio | misc | client
print // // broadcast // film

SITE MAP

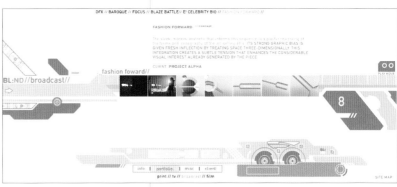

DFX // BAROQUE // FOCUS // BLAZE BATTLE// E! CELEBRITY BIO // FASHION FORWARD //

FASHION FORWARD

CLIENT **PROJECT ALPHA**

fashion foward//

BL:ND//broadcast//

info | portfolio | misc | client
print // tv // broadcast // film

SITE MAP

DFX // BAROQUE // FOCUS // BLAZE BATTLE// E! CELEBRITY BIO // FASHION FORWARD //

DFX/DIRECT EFFECT

CLIENT **PROJECT ALPHA**

dfx//

BL:ND//broadcast//

info | portfolio | misc | client
print // tv // broadcast // film

SITE MAP

BL:ND // film:<

DOGTOWN // LAFF // SPLENDOR // ISLAND OF DR. MOREAU // ERASER // SAVING PRIVATE RYAN //

SPLENDOR // message.

Interlaced bodies bathe in vibrant colors revealing not two but three
lovers, declaring a modern, uninhibited view of sexuality. THE GRACEFUL, ROUNDED TYPOGRAPHY
TEMPERS THIS CONTEMPORARY ATMOSPHERE WITH A NOSTALGIC NOD TO INNOCENCE OF THE
PARADISE LOST DURING THE 70'S.

CLIENT. GREGG ARAKI

info | portfolio | misc. | client
print // tv // broadcast // film

SITE MAP

BL:ND // film:<

DOGTOWN // LAFF // SPLENDOR // ISLAND OF DR. MOREAU // ERASER // SAVING PRIVATE RYAN //

SAVING PRIVATE RYAN // message.

Choreographed to a simple, deliberate cadence, fragments of a portentous
telegram are WOVEN TOGETHER WITH EMOTIONALLY-MUTED STILLS FROM THE MOVIE,
EXPRESSING THE ANGUISH AND TRAGEDY OF WAR.

CLIENT. GOODSPOT

info | portfolio | misc. | client
print // tv // broadcast // film

SITE MAP

BL:ND//film:<

DOGTOWN // LAFF // SPLENDOR // ISLAND OF DR. MOREAU // ERASER // SAVING PRIVATE RYAN //

SAVING PRIVATE RYAN @ concept.

this sequence is a somber, somewhat abstract treatment of a well-known
feature film WOVEN TOGETHER WITH EMOTIONALLY-MUTED STILLS FROM THE MOVIE,
EXPRESSING THE ANGUISH AND TRAGEDY OF WAR.

CLIENT. GOODSPOT

info. | portfolio | misc. | client

print // tv // broadcast // film

SITE MAP

BL:ND

typography/design/production
for moving images.

info. | portfolio | misc. | client

fun // links // messages

SITE MAP

http://code-design.com

beyond interface

writings

Museums
and the Web
1998

jennifer . trant + david . bearman
Museums and the Web and beyond interface

steve . dietz
beyond interface : net art and Art on the Net I
beyond interface : net art and Art on the Net II

susan . hazan
From Sacred to the Profane: Mark Amerika and Udi Aloni
Are the Engineers Holding hands with the Artists?

randall . packer
Net Art as Theater of the Senses
A HyperTour of Jodi and Grammatron

steve . dietz
Curating (on) the Web: Museums in an Interface Culture

Jury/Steering Committee & Credits
Archive: Call for Submissions
Press

Q1.
What is it about this site (comfortaction.com) that makes it different from others?

Comfortaction is not about gift-wrapping; it's what you'll find inside the box that matters. It exists to showcase projects rather than being a project in itself.

Q2.
What made you come up with this approach? Inspiration?

I wanted a simple site that would be organic, easy to update and easy to change to reflect my mood swings. The design was born out of what I needed and that's what inspired it.

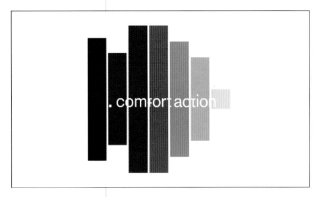

Q3.
If you were president of the World Wide Web what changes would you make?

I would match up designers without ideas with people that have something to say.

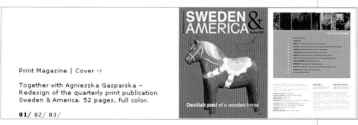

Print Magazine | Cover ->

Together with Agnieszka Gasparska –
Redesign of the quarterly print publication
Sweden & America. 52 pages, full color.

01/ 02/ 03/

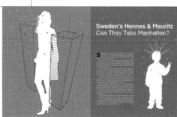

Print Magazine | H&M Article ->

The magazine features articles on Swedish
culture for an American and Swedish-
American readership.

01/ **02**/ 03/

Q4.
What is your best digital idea or project to date?

www.voice.aiga.org
www.flrt.com and
www.eyebeam.org

Q5.
Tell us about yourself: age, nationality, interests; anything that makes you different?

I'm a 28-year-old angry Swede. I like to run. I wear a mouthpiece when I sleep. I live in NY but I really want to live in a tiny village in Sweden like Ingmar Bergman.

Q6.
List of your favorite web sites and why.

I love www.fischerspooner.com
Because they're my idols.

I love www.swedengraphics.com
And I want their skills.

I love www.vbureau.com
Because they have something to say.

Q7.
What's wrong with most web sites?

They either don't say anything at all or try to say everything at once within an 800 by 600 box. Too many sites think that they will be what everybody uses for everything, but you know, I'm not going to check my horoscope on Wells Fargo's homepage. Most web sites look like hell 'cause they were designed by some crazy people in the marketing department.

About them:
I'm part of a design collective called Flat
(www.flat.com) based in NY (Chinatown).
Key members are myself, Tsia Carson,
Doug Lloyd and Kirsten Hudson.

This poster was designed as part of
Barbara Galuber's Experimental Typography
class at Cooper Union. The project features
a futuristic type movement – Gothic
Modernism, born out of a intercourse of two
stylistic opposites from two different
centuries.

01/ 02/

Future type movement | poster ->

These clips are 3 experimental
identity spots for an interactive
television network devoted to
computer and video game culture.

the clips are about 500 K each.

music by:
DJ Shadow, Air, Funk Doobiest

© petter ringbom

IDE WITH THE DIFFERENT VERSION OF THE STORY.

http://d3d2.com

Q1.
What is it about this site (d3d2.com) that makes it different from others?

We try to create a scene of reality that doesn't exist anywhere else. We try not to be too abstract, or too real.

Q2.
What made you come up with this approach? Inspiration?

The thought that a designer should first offer something that the viewer can relate to, and then distort it beyond their imagination.

Q3.
If you were president of the World Wide Web what changes would you make?

Difficult question. If you were in charge of a growing, constantly changing organism, what would you do? Try to bring it to equilibrium, until it can handle itself. (Make the surface looks pretty for now.)

Q4.
What is your best digital idea or project to date?

The one I'm working on right now. Sorry, I can't tell you about it yet.

Q5.
Tell us about yourself: age, nationality, interests; anything that makes you different?

Age 23. Born in Tokyo, raised in South East Asia, educated in Western Europe.

Q6.
List of your favorite web sites and why.

www.mox.fr entertaining
Very well crafted, great talent from Montpellier.

www.neeneenee.de/pixel/
No reason, just really like it, too bad it's frozen...

www.hungryfordesign.com
He evolves very fast. Can't wait to see what's next

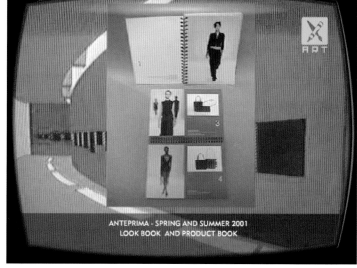

ANTEPRIMA - SPRING AND SUMMER 2001
LOOK BOOK AND PRODUCT BOOK

Q7.
What's wrong with most web sites?

Nothing, it just reflects the limit of infrastructure and building tools.

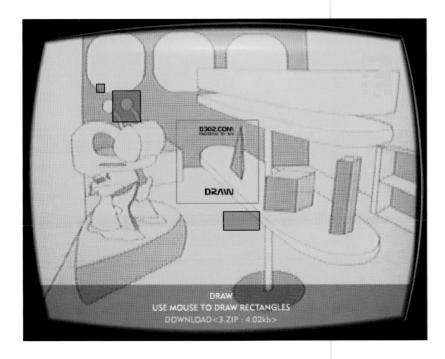

www.dandad.org/gettyonebloodbank

Q1.
What is it about this site (dandad.org/gettyonebloodbank) that makes it different from others?

Unlike other sites the D&AD gettyone bloodbank web site is a completely free service for young creatives looking for employment in the design and advertising industries. It also provides a free search service for the design and advertising industries and an on-line matchmaking service for copywriters and art directors.

Q2.
What made you come up with this approach? Inspiration?

D&AD recognized that there was a need to help kick start the careers of emerging talented young creatives. The bloodbank offers young creatives a chance to showcase their work and to get them recognized and seen by potential employers.

Q3.
If you were president of the World Wide Web what changes would you make?

More high-speed Internet connections across the world and free Internet cafes.

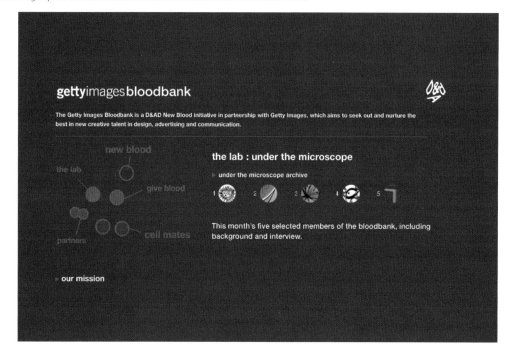

Westminster Online - still 1/1

Taking Type for a Walk' - still 4/4

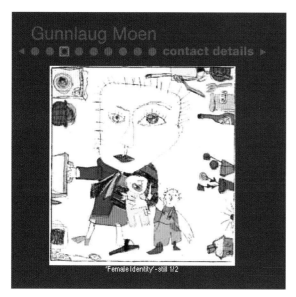

'Female Identity' - still 1/2

Q4.
What is your best digital idea or project to date?

Definitely the D&AD gettyone bloodbank and the concept behind the cellmates section of the web site. Also exciting development planned for phase two of the bloodbank. These will go live around July 2001.

Q5.
Tell us about yourself: age, nationality, interests; anything that makes you different?

28, British, Graduate Program Manager for D&AD. Interested in discovering and showcasing the best new talent across all creative disciplines.

Casserole & Pasta Hoops (condensation) - still 2/2

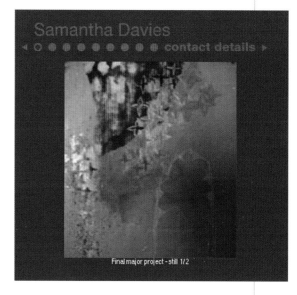

Final major project - still 1/2

About them:
D&AD is based in Vauxhall, London. We are an educational charity working to improve the standard of design and advertising across the world. Most famously known for our professional awards, the Yellow Pencils.

Q6.
List of your favorite web sites and why.

www.thedesignersrepublic.com
Definitely the most original web site I've found. Even though it's sometimes hard to find the information you want, you always have fun trying!

www.adcritic.com
For always showcasing some of the funniest and entertaining ads.

www.dandad.org
For being the best managed and most useful resource for budding young designers, art directors and copywriters.

Q7.
What's wrong with most web sites?

Too general a statement really. A lot lack real direction and objectives, others take far too long to download, and some are just far too badly designed and cluttered.

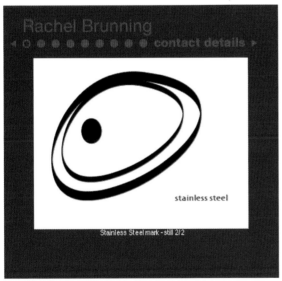

www.dctrl.com

Q1.
What is it about this site (dctrl.com) that makes it different from others?

Is it? Maybe it's the mix, the diversity of business and funky style, of content and experiment.

Q2.
What made you come up with this approach? Inspiration?

The site shows the kind of clients we like to have. Trendy, youth-inspired brands with an approach for cutting-edge design. Inspiration? Open the eyes. Look around at the world surrounding us.

Q3.
If you were president of the World Wide Web what changes would you make?

End the browser ghetto, support the standards, no more plug-in's and destroy the on-line advertising! The rest is ok!

Q4.
What is your best digital idea or project to date?

We are trying to realize personal projects in the field of the convergence of the Internet, broadband, motion graphics and TV. Another thing we are very interested in is the idea of wireless, dynamically generated, location independent, and customized information.

Q5.
Tell us about yourself: age, nationality, interests; anything that makes you different?

Roberto Eberhard (CCO, 33, Swiss) likes viper girls and goldfishes. Andreas A. Lorenz (COO, 33, Austria) likes people with ideas and personal style.

Q6.
List of your favorite web sites and why.

We are of course fond of "the big players" of (motion) graphic design. We have no favorite, there are too many creative people out there.

Q7.
What's wrong with most web sites?

Bad design, boring content and no entertainment at all!

104

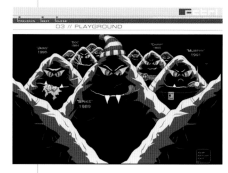

About them:

DCTRL - INTERACTIVE MEDIA AND MOTION GRAPHICS is an Internet content developer, specializing in motion graphics and based in Zürich/Switzerland. We provide a full range of consulting, development and production services that handle all aspects of on-line digital entertainment delivery. DCTRL produces web sites, mobile solutions, e-commerce, on-line branding, digital applications, streaming video, games and interactive motion graphics in 2D and 3D for any devices and the visual needs of modern society.

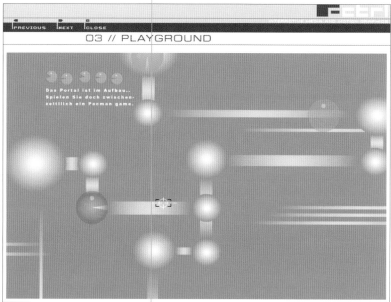

www.deconcept.com

Q1.
What is it about this site (deconcept.com) that makes it different from others?

I don't try to make my site different. I just post things that I am working on, or think are interesting.

Q2.
What made you come up with this approach? Inspiration?

I liked the idea of posting things as I made them. There were a few other web sites around that did the same thing, and I just liked the idea so much, I decided to try it out.

Q3.
If you were president of the World Wide Web what changes would you make?

Nothing.

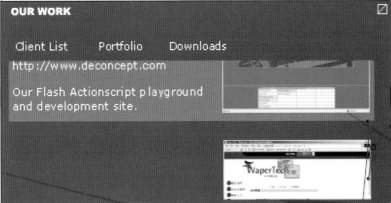

Q4.
Tell us about yourself: age, nationality, interests; anything that makes you different?

I am 23, live in the USA, and like the Internet.

Q5.
List of your favorite web sites and why.

I can't think of any.

Q6.
What's wrong with most web sites?

It's not that there is anything wrong, just that they could always be better.

redesign

new features:

- menu auto-hides if inactive
- background changes color to match experiment
- minimum resolution of 800x600 required
- menu will stretch to fit on higer resolutions
- sliding experiment chooser (experiments are sorted by month, not by day)
- Season Color™ (so you know what time of year it is)

I will not be releasing the source to the menu until I redesign the site. I will however, be remaking most of the older experiments that were done in Flash 4 as Flash 5 files. I will also be archiving the old site, so you will still have access to the old files.

Please let me know if you find any major problems with the site - geoff@deconcept.com

deconcept | dot | com

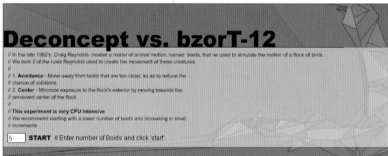

Deconcept vs. bzorT-12

// In the late 1980's, Craig Reynolds created a model of animal motion, named *boids*, that he used to simulate the motion of a flock of birds.
// We took 2 of the rules Reynolds used to create the movement of these creatures.
//
// 1. **Avoidance** - Move away from boids that are too close, so as to reduce the
// chance of collisions
// 2. **Center** - Minimize exposure to the flock's exterior by moving towards the
// perceived center of the flock
//
// **This experiment is very CPU intensive**
// We recommend starting with a lower number of boids and increasing in small
// increments

| 5 | **START** // Enter number of Boids and click 'start'

DECONAMP

I finally got around to making a Winamp skin. Here it is:DeconAmp. If you already have Winamp installed, just click this image and choose "open from current location". That should open Winamp and install the skin.

Enjoy!

(click this image to download)

OFFF : THE AFTERMATH

SPIDERINTERACTIVE
NEW MEDIA DESIGN

Spider Interactive is live.
After more than a year, it has come back to life and is open for business.

www.deformat.de

Q1.
What is it about this site (deformat.de) that makes it different from others?

There are so many design related link-logs out there. Ours just logs national sites from Germany.

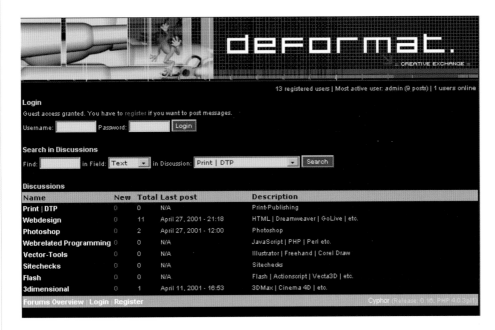

Q2.
What made you come up with this approach? Inspiration?

First of all I was inspired by all the other design-e-zones, link-logs and personal playgrounds
that are there. I just wanted to take part in the worldwide web design movement.

Q3.
If you were president of the World Wide Web what changes would you make?

Standardize browsers and force all users to update to the most actual version.
Well, I know that's morally not correct but it would make things easier for all
of us web developers.

Q4.
What is your best digital idea or project to date?

deformat.de

Q5.
Tell us about yourself: age, nationality, interests; anything that makes you different?

Age 30, German, interests: veggie food, cooking, playing soccer with my one-year-old son Nik, and smoking strong French cigarettes.

Q6.
List of your favorite web sites and why.

gmunk.com
Because he inspired me most.

linkdup.com
Because they do the best logging job.

airbagcraftworks.com
Because it's the most unusual product presentation site I've seen so far.

Q7.
What's wrong with most web sites?

Style.

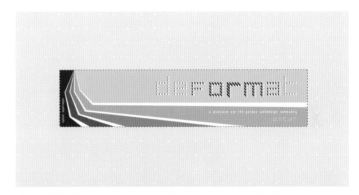

www.designgraphik.com

Q1.
What is it about this site (designgraphik.com) that makes it different from others?

The name.

Q2.
What made you come up with this approach? Inspiration?

I was bored. Everything.

Q3.
If you were president of the World Wide Web what changes would you make?

Nothing.

Q4.
What is your best digital idea or project to date?

None of them.

Q5.
Tell us about yourself: age, nationality, interests; anything that makes you different?

23. American. I like Thai chili sauce on everything.

Q6.
List of your favorite web sites and why.

dextro.org
Visual.

washingtonpost.com
Information.

progressive.com
Car insurance on-line.

Q7.
What's wrong with most web sites?

I don't know, what is wrong?

126

BROTHAS AND SISTAS
SUBMETHOD VIR2L KIIROI HOLODECK PURUS LIFTINGFACES
ARTISTICA PRAYSTATION GMUNK 知ILIIDV VITAFLO

www.designiskinky.net

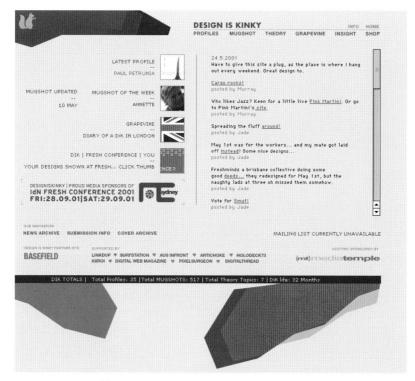

Q1.
What is it about this site (designiskinky.net) that makes it different from others?

I think we have an easygoing and sarcastic attitude to the web design scene that a lot of people enjoy. We don't take it too seriously and treat it how it is meant to be treated by having fun. We also think that the content on the site stands out as it is all very interesting and intelligent content that gives people a chance to learn things not just stare at pretty pictures.

Q2.
What made you come up with this approach? Inspiration?

I came up with the approach for Design is Kinky really just as a way to get involved and also as an extension of my own personality. Both Jade and I are smart arses and that is what the site mirrors. We are always ourselves and that is the approach we will always take.

We are always inspired by our peers and the people around us. Our ideas are our own but we accept that they all evolve from some influence whether conscious or not. We were inspired by everyone who came before us and we are continually inspired every day.

134

Q3.
If you were president of the World Wide Web what changes would you make?

None really. I think if you start making changes to things for personal reasons then you will end up ruining everything. The best thing about the web is that everyone can voice their opinion or show their talent. No matter how different your views may be the web allows anyone to have a voice. If you try to change this and censor something then you will ruin the whole concept of the web.

Q4.
What is your best digital idea or project to date?

Definitely Design is Kinky. It is the best digital thing I have and probably will ever create. I am incredibly happy with it and have no thoughts of slowing down.

Q5.
Tell us about yourself: age, nationality, interests; anything that makes you different?

Me? I am a 27-year-old Australian designer. I have a broad range of interests so I won't bore you by listing them.

Q6.
List of your favorite web sites and why.

www.destroyrockcity.com
Amazing illustrations.

www.surfstation.lu
Shows the depth of the design community.

www.gmunk.com
Broadband Flash craziness.

Our organization is not really an organization. It is simply a web site that myself and Jade Palmer run in our spare time for fun and the love of it. We are located in Australia, myself in Sydney and Jade in Melbourne.

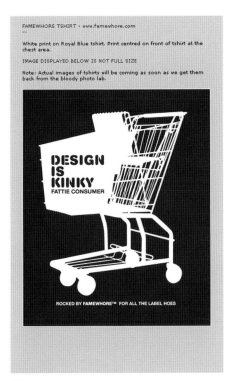

FAMEWHORE TSHIRT - www.famewhore.com
--

White print on Royal Blue tshirt. Print centred on front of tshirt at the chest area.

IMAGE DISPLAYED BELOW IS NOT FULL SIZE

Note: Actual images of tshirts will be coming as soon as we get them back from the bloody photo lab.

DESIGN IS KINKY
FATTIE CONSUMER

ROCKED BY FAMEWHORE™ FOR ALL THE LABEL HOES

Q7.
What's wrong with most web sites?

Well, it depends what you're looking for. In design terms, probably 80 – 90% of the internet could do with a redesign but not everyone cares about design and that is fine. However I think functionality and navigation could be improved across the web. I'm no useability Nazi like Jakob Nielsen but unless the site is some art piece that is meant to be chaotic a site should still work well and the structure is very important.

Layer 4
--
I cut out bits of her arms to make her look more bionic.

Layer 4

Layer 5
--
I brought in more of the robot scans and played with her right side, adding the robotic arm elements and darker tones to give her more shape, body and weight and basically not look so flat.

Layer 5

Finished image
--
I had to create a mock logotype. The typeface is one of Buro Destructs. I flipped an "i" to make the typeface more dynamic and the logotype a lot stronger. I also added more texture behind her to add more depth to the image.

Justin Fox - www.australianinfront.com.au

b!onic
01

Final Image

www.digitalorganism.com

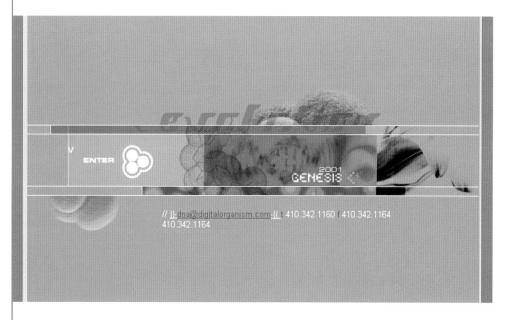

Q1.
What is it about this site (digitalorganism.com) that makes it different from others?

The answer to this question is better answered by the end-users.

Q2.
What made you come up with this approach? Inspiration?

David Rokeby, a front-runner of interactivity, has been creating interactive experiences since 1982. Rokeby is one of the most influential and inspirational persons that I have the pleasure of coming in contact with.

His experiments in interactivity have influenced my thoughts for the future of the Internet. Human bodies drive the interactive experiences that Rokeby creates. The first generation of this ideal was in 1983, when he introduced 'Reflexions.' This system was constructed out of an 8x8 pixel video camera, connected to a re-wrapped card in the Apple II. The movements detected by this system triggered simultaneous sound events and produced visual abstract textures and patterns. Systems with human interaction dictating the experience, such as Rokeby's, represent an ideal of digitalorganism®.

Q3.
If you were president of the World Wide Web what changes would you make?

I would resign, and hire more political people to fill that position.

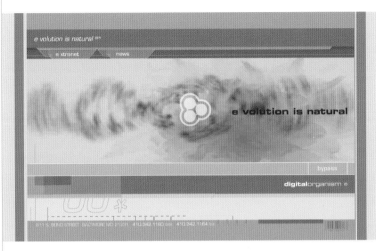

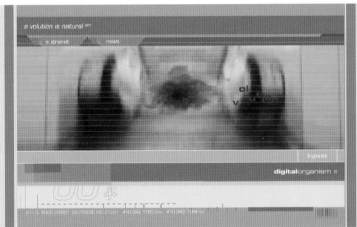

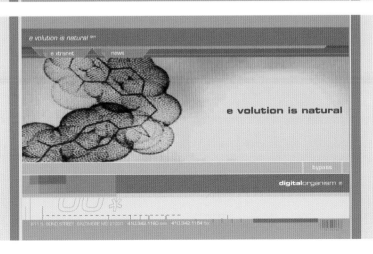

Q4.
What is your best digital idea or project to date?

That's a tough question. I am really proud of all the proje
that come out of digitalorganism®, but if I had to pinpoir
one particular project it would be our promotional CD-RC
This piece has not been released to the general public ye
but I feel it allowed us to really show off our capabilities i
the area of motion design, interactivity, and the combinir
of the on-line and off-line worlds.

Q5.
Tell us about yourself: age, nationality, interests; anything that makes you different?

Age: 26 years old
Nationality: American
Interests: mountaineering, and white water kayaking.

Q6.
List of your favorite web sites and why.

google.com
altavista.com
k10k.com

Q7.
What's wrong with most web sites?

I don't feel I am qualified to judge other people's work. You tell me.

140

About them:

Digitalorganism designs, develops and creates interactive multimedia content in the newest/most technologically advanced format. Our concentration is directed at the creation of organic image content through the design and development of customized solutions that embody multiple communications and media formats to stimulate an intense viewer/user encounter. Through our reputable style we creatively produce signature enterprise identities through presentations that induce the most compelling and effective user-centric experience. The nucleus of our developmental success is the integration of the human element into the technological domain to generate interactivity never before witnessed or experienced.

Our focus is on developing the best interactive business solutions for our clients through our consultation and needs analysis process, which will determine the most effective delivery mediums to reach their target audience. We are fluent in the creation of content for multiple delivery avenues, either over the web, through an intranet, on a laptop, or in a kiosk. The key is to effectively display our clients' messages in a viewing format suitable for their intended audience.

The benefit to our clients and their end users is the increased amount of information retained by their target audience. In this manner, digitalorganism will strengthen our clients' relationships with their customers through interactive multi-media presentations that more effectively convey the intended message via advertising, education, and marketing. This also affords organizations the ability to distribute their message cost-effectively on a consistent basis, without limit to the size of the target audience.

www.droogdesign.nl

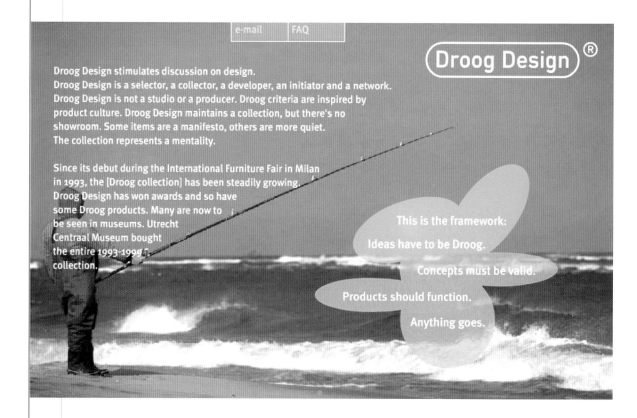

e-mail FAQ

Droog Design ®

Droog Design stimulates discussion on design.
Droog Design is a selector, a collector, a developer, an initiator and a network.
Droog Design is not a studio or a producer. Droog criteria are inspired by
product culture. Droog Design maintains a collection, but there's no
showroom. Some items are a manifesto, others are more quiet.
The collection represents a mentality.

Since its debut during the International Furniture Fair in Milan
in 1993, the [Droog collection] has been steadily growing.
Droog Design has won awards and so have
some Droog products. Many are now to
be seen in museums. Utrecht
Centraal Museum bought
the entire 1993-1999
collection.

This is the framework:

Ideas have to be Droog.

Concepts must be valid.

Products should function.

Anything goes.

Q1.
What is it about this site (droogdesign.nl) that makes it different from others?

One of the main things to do is to find a story behind the message or the information. Droog Design is an experimental design agency. They work internationally and use "dryness" (sort of normalness) as a key text in their communication. In order to create understanding of the viewer on the site I choose images from landscapes with water and people fishing. The people are a symbol for the Droog Design organization, the fishing waters for their experiments with briefings, designers and companies (they are fishing in different waters). The landscapes bring the normal environment in which nevertheless beautiful new things are developed.

Q2.
What made you come up with this approach? Inspiration?

Personal intuition, orientation and the will to create reduced stories with a high image.

Q3.
If you were president of the World Wide Web what changes would you make?

Change nothing. And I hope there will never be a president with ministers that discuss away the personal energy of people.

Q4.
What is your best digital idea or project to date?

Digital working is on show every day. We use it for all sorts of communication, but always within the context of design. We create every day many graphic products, or digital animations for product design. I am very happy with the way the Droog Design site came out!

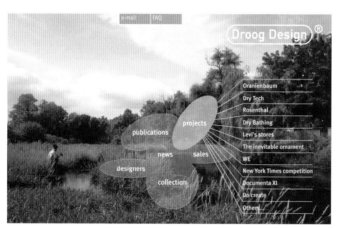

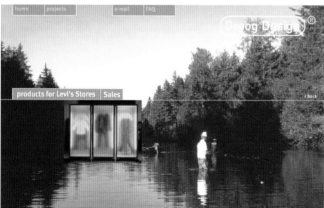

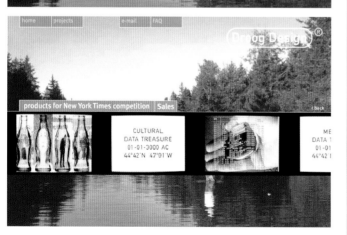

Q5.
Tell us about yourself: age, nationality, interests; anything that makes you different?

44 years old, male, Dutch, working internationally in a high-end design quality context. I am one of the partners of Ontwerpwerk office for design (24 people working on graphic, environmental, industrial and interaction design), I head Foundation Products of Imagination (everything between design and art), I give international design workshops (for Vitra Design Museum in France, UQAM Montreal, summer workshops New Zealand...) and last but not least I am head of the newly started Masters program FunLab at the design academy in Eindhoven. FunLab researches the meaning of entertainment and will come up with new concepts for experience and entertainment in the future.

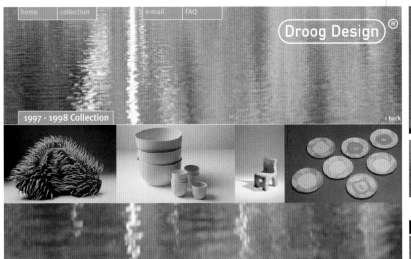

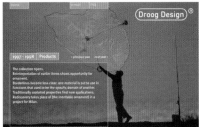

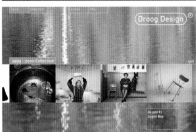

Q6.
List of your favorite web sites and why.

Every day I see some new sites on the web. I only try
to survey within my own work. Yesterday I saw
www.mossonline.com. Great way of showing products.
Funny, informative and fast.

Q7.
What's wrong with most web sites?

Dull, people seem to do without thinking. There are
almost no nice stories. I guess we need to see the web
as a great opportunity to create little movies, little
choreographies, and little stories.

www.e23design.de

Q1.
What is it about this site (e23design.de) that makes it different from others?

My site is just different from others through its design. Content is so often the same, splash, own artwork, news, links, featured artwork, etc... The left part of the site is some 45 angle stuff that got a light 3D form in it while the right part is only folded paper.

Q2.
What made you come up with this approach? Inspiration?

I tried out different designs using the folded paper. My third attempt to this was the current site. It looked good so I worked with it. The paper was used because I didn't want to make it look like a plain news text. Some of my sketches are on paper. I also put down nice urls on paper to remember them. I wanted the site to be my personal notepad everyone's gonna read from.

Q3.
If you were president of the World Wide Web what changes would you make?

I'd erase all the shit that's on the web.

Q4.
What is your best digital idea or project to date?

I love to see collaborational projects where styles are mixed together well.

Q5.
Tell us about yourself: age, nationality, interests; anything that makes you different?

I'm 18 and live in Germany. Like many other students, I learned to work with the computer mostly by myself in my free time. I am trying to find the "key to all forms of rocking" in the available media around myself.

Q6.
List of your favorite web sites and why.

www.surfstation.lu
I like this site a lot. When I have time to browse some fresh artwork I often go to surfstation, easy design and top content.

www.orangebleu.net
Christophe always has some awesome ideas that amaze me.

www.thehorusproject.com
Is also one of my favorites. The site features lots of complex and stylish pieces.

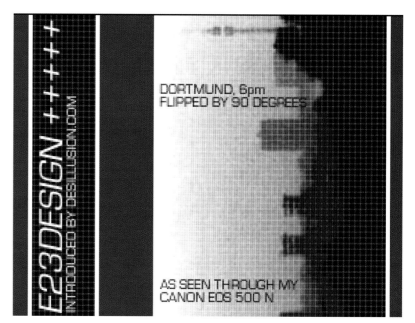

Q7.
What's wrong with most web sites?

Speaking of artwork, a lot of sites copy stuff off from others and claim it as their own. Some think that they are artists because they have the ultimate recipe for art. Some think that their stuff is interesting just when they put up a hundred links to the original thinkers. That kinda pisses me off sometimes.

About them:

Germany, no office, one member
(me), no awards just some artist of
the day/week stuff.

www.eboy.com

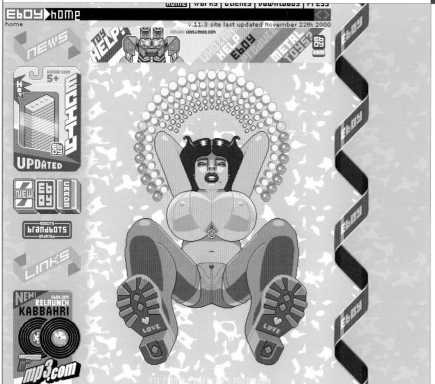

Q1.
What is it about this site (eboy.com) that makes it different from others?

We decided to only show our free work on our site. We feel that showing work for clients can be boring. We respect our visitors and show them work explicitly done for them. The themes reflect what eBoys are interested in. Monsters, building cities, guns and girls of course.

Q2.
What made you come up with this approach? Inspiration?

Our inspiration is POP or popular culture. We love supermarkets, shopping, TV-zapping, network gaming, playstations, etc. We get inspired by ugly buildings rather than by other designers. A cookie package can be a main source for a project.

Q3.
If you were president of the World Wide Web what changes would you make?

No change.

Q4.
What is your best digital idea or project to date?

The concept of our site. It keeps us having fun.

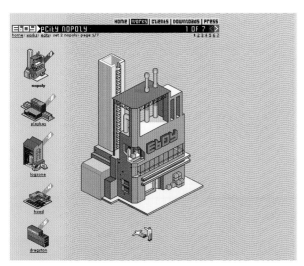

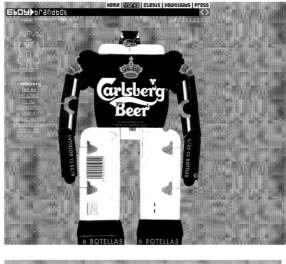

Q5.
Tell us about yourself: age, nationality, interests; anything that makes you different?

We're not different. Just four guys as many others. There's Steffen '67, Svend '67, Kai '64 in Berlin and Peter '67 in New York.

Q6.
List of your favorite web sites and why.

epinions.com. Because it is not thinkable without the Internet, it is beautifully designed, very useful and truly democratic.

The Lego fan pages in general. People showing their own LEGO models.

Q7.
What's wrong with most web sites?

Nothing's wrong. People are different — and so are web sites.

www.factory512.com

Q1.
What is it about this site (factory512.com) that makes it different from others?

I don't know. F512 is about nothing and everything. It is about what happens on my scene
and in my life. And it's not my right to decide what's different or not. I do what I wanna do.
It's my world, but anyone may be my friend. So, F512, in the beginning it was a personal
inspirational site, playground. Then F512 developed to a scene zine, full of scene news. Then
F512 died as a zine and was reborn as a one-standing projects accumulator—the projects
dedicated to what happened on scene and in real life.

Q2.
What made you come up with this approach? Inspiration?

Real life and other people's behavior.

Q3.
If you were president of the World Wide Web what changes would you make?

I have no ambitions to be a president or any other politician gangsta. I hate politics. In Russia we have a very corrupted political scene.

Q4.
What is your best digital idea or project to date?

F512 is my best digital idea and a project anyway.

Q5.
Tell us about yourself: age, nationality, interests; anything that makes you different?

I'm 26-year-Russian. Stop here.

Q6.
List of your favorite web sites and why.

F512
You know why.

Surfstation
My friends are there.

AdCritic
It gives me food for thought and some interesting ideas for work.

Q7.
What's wrong with most web sites?

What web sites? Dotcoms? They're wrong from their basis. Design portals? Read
a FUCK.CORPORATE project at F512.

About them:

I'm a creative director for Quantum Art, Inc, a big business software builder. I work in my company's Moscow office. Awards? What awards? I hate ceremonies.

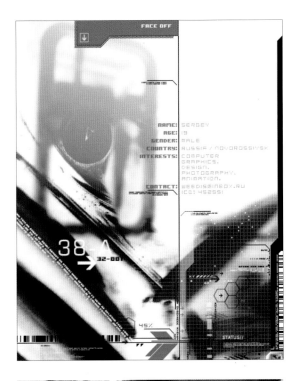

www.flipflopflyin.com

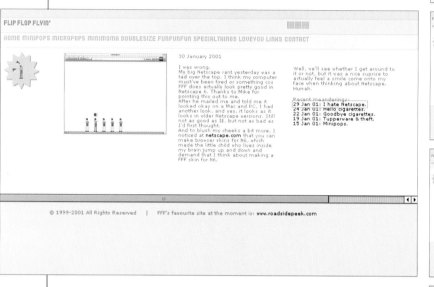

HOME MINIPOPS MICROPOPS MINIMOMA DOUBLESIZE FUNFUNFUN SPECIALTHINGS LOVEYOU LINKS CONTACT

30 January 2001

I was wrong.
My big Netscape rant yesterday was a tad over the top. I think my computer must've been tired or something cos FFF does actually look pretty good in Netscape 6. Thanks to Mike for pointing this out to me.
After he mailed me and told me it looked okay on a Mac and PC, I had another look, and yes, it looks as it looks in older Netscape versions. Still not as good as IE, but not as bad as I'd first thought.
And to blush my cheeks a bit more. I noticed at **netscape.com** that you can make browser skins for N6, which made the little child who lives inside my brain jump up and down and demand that I think about making a FFF skin for N6.

Well, we'll see whether I get around to it or not, but it was a nice suprise to actually feel a smile come onto my face when thinking about Netscape. Hurrah.

Recent meanderings:
29 Jan 01: I hate Netscape.
24 Jan 01: Hello cigarettes.
22 Jan 01: Goodbye cigarettes.
19 Jan 01: Tupperware & theft.
15 Jan 01: Minipops.

© 1999-2001 All Rights Reserved | FFF's favourite site at the moment is: **www.roadsidepeek.com**

Q1.
What is it about this site (flipflopflyin.com) that makes it different from others?

Flip Flop Flyin' loves Singin' In The Rain.

Q2.
What made you come up with this approach? Inspiration?

Years of perfecting the art of not growing up. Inspiration? Brian Wilson, Gene Kelly and Harry Nilsson.

Q3.
If you were president of the World Wide Web what changes would you make?

I'd make Netscape illegal.

Q4.
What is your best digital idea or project to date?

www.flipflopflyin.com
www.ilovecolette.com

Q5.
Tell us about yourself: age, nationality, interests; anything that makes you different?

Age, 30 years old.

Nationality
English.

Interests
Smiling, dancing, looking and walking.

Anything that makes you different? Very much enjoy films where Tom Hanks and Meg Ryan fall in love.

About them:

The organization is I, I am based in Berlin. I got a bronze medal for the 50m freestyle at Lincoln Pentaqua swimming club when I was a kid.

Q6.
List of your favorite web sites and why.

www.k10k.com
www.maganda.org
www.delaware.gr.jp
Because they all, in one way or another, show us something personal.

Q7.
What's wrong with most web sites?

No heart.

pretend to be jesus

go sledging

do prank starjumps next

hug a stranger next

ELVIS

dress like elvis next

photocopy your head next

164

FRANCE

1. EDGAR DAVIDS 2. STEVE McMANAMAN 3. ABEL XAVIER 4. LILIAN THURAM 5. PIERLUIGI COLLINA 6. F. LJUNGBERG

7. P. SCHMEICHEL

8. CARSTEN JANCKER 9. HAKAN SUKUR 10. GHEORGHE HAGI 11. RAUL 12. KAREL PODORSKY 13. SAVO MILOSEVIC

www.fork.de

⇢ m4de in b%ndesrepublik ⬍

⇢ **FORKUNST4BLEM3DIA**
ENTER FORK OVERDOPE VERSION

⇢ **FORKBUS1NESSCLA$$**
ENTER STRAIGHT-LACED VERSION

⇢ HAMBURG HEADQUARTERS

JULIUSSTRASSE 25
22769 HAMBURG, GERMANY
PHON +49.40.432.948.0
PHAX +49.40.432.948.11
INFO@FORK.DE

⇢ BERLIN BESETZTE ZONE

WOLLINERSTRASSE 16-19, AUFGANG B 2.OG
10435 BERLIN, GERMANY
PHON +49.30.443.507.0
PHAX +49.30.443.507.11
INFO@FORK.DE

⇢ NEW YORK SYSTEM EXTENSION

184 KENT AVENUE, FIFTH FLOOR, 5B
BROOKLYN, NY 11211
PHON +01.917.972.4840
PHAX +01.718.384.1402
NEWYORK@FORK.DE

⇢ FULL-CONTACT.

⇢ STYLE WARS.

⇢ GAMES WE PLAYED.

⇢ Cologne

Native Instruments, Fork, Warp Rec. : Reaktor GUI Redesign: Pre-Release! : 14. Stuttgarter Filmwinter : MedienAkademie

▼4RK

COLOR SYSTEM

TH3 IRON CURTA1N

RIDE WWW.FORK.DE
VERSION 4.1

Q1.
What is it about this site (fork.de) that makes it different from others?

Can't really answer that, you guys have to decide...don't like comparing my work to theirs...

Q2.
What made you come up with this approach? Inspiration?

The approach for the site is basically just to experiment with interface structures, I mean, the key thing for the web is the interactivity, isn't it, like to find new ways of navigations that somehow show new ways of displaying information, well, or just to play around with different navigational systems...

Q3.
If you were president of the World Wide Web what changes would you make?

Overrule the president!

Q4.
What is your best digital idea or project to date?

Don't really know, I tend to be not satisfied with my work in the end, therefore, again, you guys have to decide, probably…

Q5.
Tell us about yourself: age, nationality, interests; anything that makes you different?

25, German.

168

About them:

No office, I'm the one and only key member...

Q6.
List of your favorite web sites and why.

Great job on combining all these pieces and finding an explorative understandable way of putting them on the web, that doesn't draw away attention with graphic content that is too and yet intense, retains the site designer's individuality and is still a nice piece of art in itself... www3.zeit.de/forest/main.html

Habbohotel is the English version of hotel kutakala, in which you are able to rent your own room, invite people over and buy furniture for the room via your cell phone, great concept behind it I think and also the graphics are pretty good too: www.habbohotel.com, just fucks around with your browser a little bit: www.membank.org

Q7.
What's wrong with most web sites?

Most web sites tend to be too business oriented. They just serve the purpose to make much money in a fast way. People don't tend to care too much anymore about the design of a site and only look at the "hits" and "clicks" that a site gets and at the commercial success of a site. That's too bad...

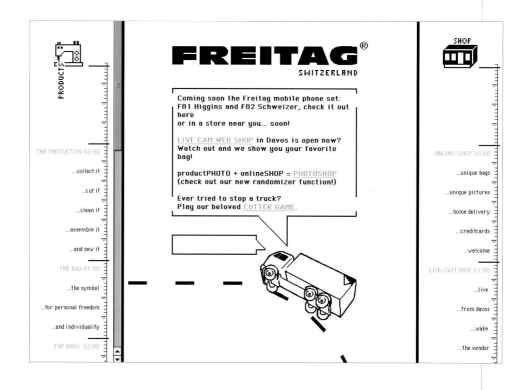

FREITAG®

SWITZERLAND

Coming soon the Freitag mobile phone set:
F81 Higgins and F82 Schweizer, check it out here
or in a store near you... soon!

LIVE CAM WEB SHOP in Davos is open now?
Watch out and we show you your favorite bag!

productPHOTO + onlineSHOP = PHOTOSHOP
(check out our new randomizer function!)

Ever tried to stop a truck?
Play our beloved CUTTER GAME.

PRODUCTS

THE PRODUCTION 00:00
...collect it
...cut it
...clean it
...assemble it
...and sew it
THE BAG 01:00
...the symbol
...for personal freedom
...and individuality
THE BROS. 02:00

SHOP

ONLINE-SHOP 00:00
...unique bags
...unique pictures
...home delivery
...creditcards
...welcome
LIVE-CAM SHOP 01:00
...live
...from davos
...wake
...the vendor

About them:

In the beginning, the whole enterprise started at home at a sewing machine. In 1995 the brothers founded their company "Freitag retour Gebr." In 1999 it changed to the form of a joint stock company by the name of Freitag lab. (as in "Laboratory" or "Label" — you choose). Today, Freitag lab. employs ten people; graphic designers, product designers, and a production and distribution team. The product line has grown to sixteen models. Cutting and packaging still happens at the Freitag lab., sewing has been outsourced to different Swiss manufacturers, one of them a manufacturer employing disabled people.

Awards:
1997 the Freitag bag was awarded the "Swiss Design Award," 1999 the award of the Swiss Foundation for Applied Arts.

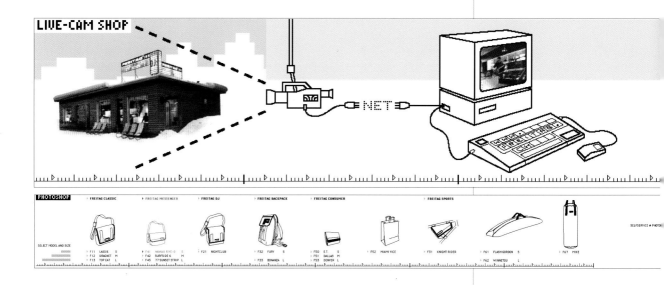

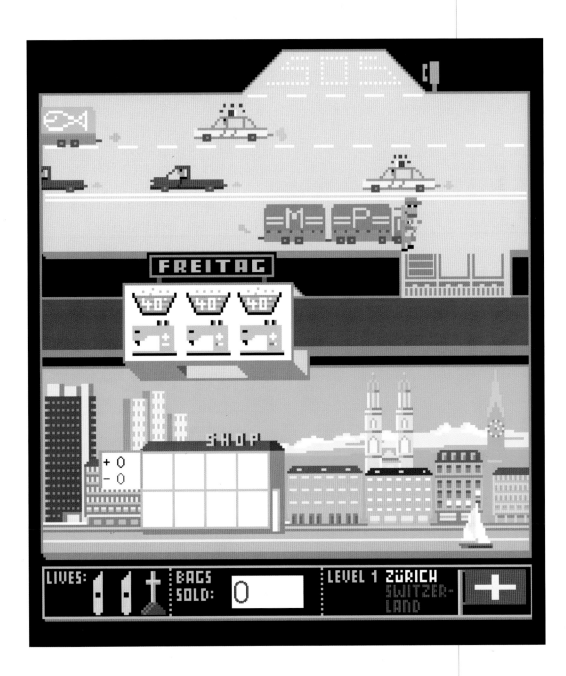

www.k10k.net

Q1.
What is it about this site (k10k.net) that makes it different from others?

The freshness and the relevance of the constantly updated design-related news, the crisp freshly squeezed flavor of the weekly issue, the personal touch and the simple mission; to keep people inspired when sitting in their dull corporate working environments, to make sure that people don't go postal, to ensure that people like Jakob Nielsen don't take over the world.

Q2.
What made you come up with this approach? Inspiration?

We simply needed a site that we wanted to visit ourselves; we needed a more up-tempo version of Digital Thread, something pricklier than SHIFT. So we made our own site. In order to keep the news flowing we figured we needed to invite other people, this is why we have people writing news from all corners of the world; to keep most of the time zones covered.

Q3.
If you were president of the World Wide Web what changes would you make?

We would start off by buying up the Netscape Corporation from AOL and make sure that any trace of Netscape Navigator/Communicator 4.x was forever erased from the Internet. We would then tell them that they were never allowed to create another browser until they were absolutely sure it actually worked, and force the former CEO to send out a personal apology to all those people who've wasted months trying to make their code work in their terrible products.

We would also send a formal letter to Macromedia to tell them to wise up, fix their horrible interfaces and make their Flash product bug free (and only available to people who promised to use it for good things, not for evil).

And, lastly, we would eliminate any form of censorship on the web. Ever.

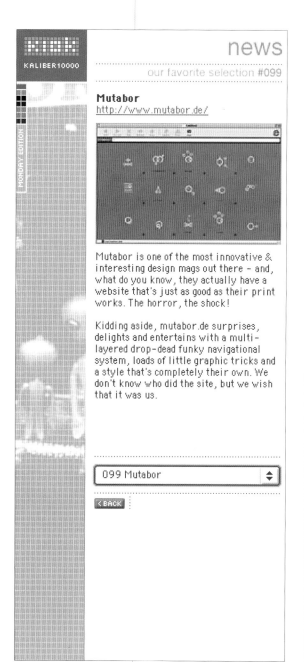

Mutabor

http://www.mutabor.de/

Mutabor is one of the most innovative & interesting design mags out there – and, what do you know, they actually have a website that's just as good as their print works. The horror, the shock!

Kidding aside, mutabor.de surprises, delights and entertains with a multi-layered drop-dead funky navigational system, loads of little graphic tricks and a style that's completely their own. We don't know who did the site, but we wish that it was us.

099 Mutabor ⇕

< BACK

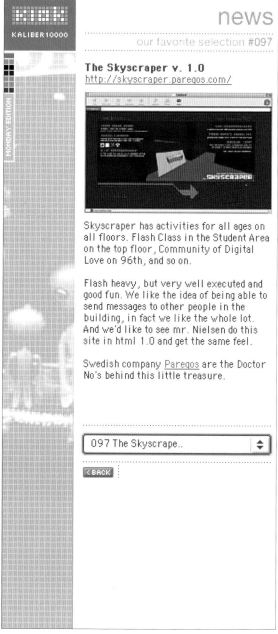

The Skyscraper v. 1.0

http://skyscraper.paregos.com/

Skyscraper has activities for all ages on all floors. Flash Class in the Student Area on the top floor, Community of Digital Love on 96th, and so on.

Flash heavy, but very well executed and good fun. We like the idea of being able to send messages to other people in the building, in fact we like the whole lot. And we'd like to see mr. Nielsen do this site in html 1.0 and get the same feel.

Swedish company Paregos are the Doctor No's behind this little treasure.

097 The Skyscrape.. ⇕

< BACK

Q4.
What is your best digital idea or project to date?

We cannot tell you about that, but, hopefully, it is a bloody good idea that will make us rich and might even make us happy. Second to that the best thing we've ever come up with is KALIBER10000. It has completely changed our lives. In a good way.

Q5.
Tell us about yourself: age, nationality, interests; anything that makes you different?

We are three Danish males, around 26 – 27, we are 2/3 bald, 1/3 touch of John Lennon, with a slight whiff of wet dog thrown in for good measure.

Q6.
List of your favorite web sites and why.

gayswithguns.com
Created by the legendary Miles & Marvin. We wouldn't be doing this if it wasn't for them. They turned us on to this whole web thing in the first place, with their wild style cowboy approach.

Space-invaders.com
The whole concept of pasting space invaders up all over the globe is just so appealing to us. And then keeping track of their beautiful vandalism on the web seems like a fantastic way of using an on-line medium.

flipflopflyin.com
So little and seamlessly simple, this site just kicks ass. We love Craig's things, his Fun Fun Fun issue on k10k was one of the best and most popular we ever had. His sense of humor is very touching and subtle.

Q7.
What's wrong with most web sites?

Most sites are incredibly dull, very bad pieces of craftsmanship, impossible to navigate, have horrible and completely useless splash pages (with no "skip intro" button,) use buggy plug-in dependent technology for crucial navigation structures, are never tested on Macs, are never tested in IE, try to sell shit to people even if their e-commerce solution only works half the time, are thought up by people who have no clue as to what the web is/can do — eager to make an easy buck, have no visions, are too ambitious and comply laid out — making it impossible for anyone to properly update and maintain it, are full of crap midi-music and animated banners you'd never click on.

About them:

KALIBER10000 (www.k10k.net), consists of three people: Michael Schmidt, Toke Nygaard and Per Jørgensen. We are based in San Francisco, London and Copenhagen, but are all originally Danish.

We don't have an office, we're not a "real" company, and yet we still manage to get by just fine.

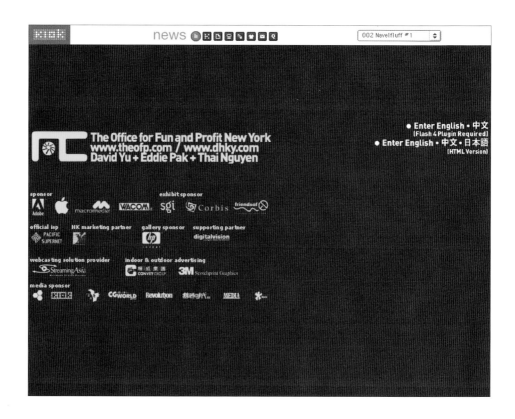

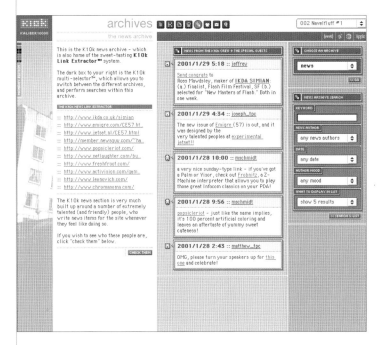

www.keicon.com

Q1.
What is it about this site (keicon.com) that makes it different from others?

Steps beyond being merely technically proficient to being a visually rich, personal exploration of natural elements and visual artistry. This is an experimental site that utilizes abstract imagery and ambient sound to deliver an amusing interactive experience.

Q2.
What made you come up with this approach? Inspiration?

Inspiration of Keicon is based on the contrast between chaos vs. peace, nature vs. technology. I found that the designs in nature are truly astonishing, so I try to incorporate some of the elements of nature into my design.

Q3.
If you were president of the World Wide Web what changes would you make?

Pick between Internet Explorer and Netscape and kill one of them for good. Until that day comes, web designers today will have to suffer from the browser differences.

Q4.
What is your best digital idea or project to date?

I don't have best projects today, it's always tomorrow in the future.

Q5.
Tell us about yourself: age, nationality, interests; anything that makes you different?

Name: Tony Ke
Age: 24
Nationality: Made in Taiwan, export to Canada.
Besides design, I love to train and fight in the ring during free time.

About them:

Q6.
List of your favorite web sites and why.

www.once-upon-a-forest.com
Because it's real digital art.

www.google.com
Because it's the best search engine.

www.surfstation.lu
Because it's the best on-line design zine.

Tony is an award-winning designer who has been in the design industry since 1996, and since then he has won prestigious awards such as Macromedia SOTD awards and is also one of the co-authors for the book *New Master of Flash* along with many other well respected designers around the world such as Joshua Davis (Praystation) and Yugo Nakamara (Yugop).

Q7.
What's wrong with most web sites?

There is nothing wrong with any web site on-line today, just like the real world. Everybody living in this world serves a purpose, either good or bad, rich or poor. Web design needs diversity in order to grow even.

www.koneisto.com

Q1.
What is it about this site (koneisto.com) that makes it different from others?

The basic idea behind the whole visual concept for Koneisto is to do visual electronic music, without any rules, without thinking target groups as the true pioneers of electronic music do. We are designers, not hard-core programmers, so we really play only with design and sound, don't even try to create some super complicated action scripts in Flash. Technically the site is very simple.

Q2.
What made you come up with this approach? Inspiration?

History of electronic music and the ideology behind the electronic music scene.

	LAVAT STAGES
1	HALLI
2	ALLAS
3	CLUB A
4	CLUB Y
5	CLUB Z
6	CLUB X
7	SEKKIS
8	PATSAS
9	IMAAMIN KEINUTUOLI
10	BOWLIN

ALUEKARTTA
MAP OF THE AREA — KUPITTAAN PUISTO

BAARIT / BARS
A HALLI
B KESKIÖ
C IMAAMI
D SEKKIS
PALVELUT / SERVICES

KUPITTAA

BY BUS

www.matkahuolto.fi

www.tlo.fi

www.turku.fi/bussit

About them:

Soumi Design is a design group of two young Finnish designers, Teemu Suviala and Antti Hinkula, both graduated from Lahti Institute of Design, Department of Visual Communication.

We have worked on various design projects: visual identities, web design, type design, illustration, editorial design, video art, etc. Music related design has always intrigued us and instead of being just designers we've tried to become visual composers.

Q3.
If you were president of the World Wide Web what changes would you make?

If we were presidents, we would rearrange the whole WWW structure, cause there seems to be something wrong with the flow of money. It's not coming to us.

Q4.
Tell us about yourself: age, nationality, interests; anything that makes you different?

Teemu Suviala, 24, Finnish. Likes to play with toy cars in sandboxes.

Antti Hinkula, 25, Finnish. Doesn't like to play with toy cars in sandboxes.

this spring i've been working as Art Engineer for KONEISTO -festival.

take a look at this wicked flash-site. here you can find all those funny animations, screensaver, typeface, and of course, programme and all necessary info about the festival.

ENTER···> WWW.KONEISTO.COM

Q5.
List of your favorite web sites and why.

We really don't have any favourites. We don't usually get influences from the web. Of course there is lot of great design on the web but it's difficult to find any unique and inspiring design. If you see some original piece of art on the web, it will take two days and the cheap copies will be everywhere, that's sad and very frustrating.

Q6.
What's wrong with most web sites?

Lack of originality, there's just too much copying.

www.lessrain.co.uk

currently under water

walter

LONDON BERLIN FISH
UK DE COM

LESS RAIN

good choice! do you have the plug-in?

– yes

no –

– download
shockwave
plug in

Q1.
What is it about this site (lessrain.co.uk) that makes it different from others?

We have been conceptualizing and building interactive spaces since 1996 and back then, our focus was on imaginative, emotional interaction rather than web design. We tried to make the technology we used invisible and focus on creating a conceptual piece rather than a container for a collection of experiments.

Lars: It is quiet, peaceful and friendly to everyone on-line.

Q2.
What made you come up with this approach? Inspiration?

Vassilios: I think it is a combination of inspiration and methodical, hard work. Building on each other's ideas, creating twists on each other's vision and fine-tuning the final result for optimal performance and economy. We wanted to have a physical navigation metaphor that would initially consist of empty slots. The slots were gradually filled with prototypes of the kind of interactive work that we wanted to be doing or abstractions of stuff that we had already done.

Lars: The beauty and silence of Death Valley.

Q3.
If you were president of the World Wide Web what changes would you make?

Vassilios: I would introduce a solid self-regulating system and then resign gloriously.

Carsten: First I would print out a hard copy of the web to store it securely in a library. After assuring that the web is now completely safe and can do without further administration, I would allocate a respectable vice president and go on vacation.

Q4.
What is your best digital idea or project to date?

Lars: It's mostly the project we are working on at present.

Q5.
Tell us about yourself: age, nationality, interests; anything that makes you different?

Vassilios Alexiou: age 32
Nationality: Hellenic
Interests: people

Lars Eberle: age 30
Nationality: European
Interests: anything I don't know yet.

For our commercial portfolio, job vacancies
and contact information proceed to:

www.lessrain.co.uk
www.lessrain.de

For general enquiries or comments, mail us at:

reception@lessrain.com

al in won

They all ask the same questions - Who is he? What
does he do? Is he famous? Why did you do these pic-
tures of him? It became so different from what it
might have been.

I didn't want to go into what Al did or who he was be-
cause the facts were not important, and even if they
were, they certainly weren't clear. Only the sense
got from being with him, from knitting together this
tapestry of what Al seemed to be, of how the chaotic
order of his life was a mirror of his own soul - of work
in progress - grand, and yet in tatters - an exiled king
a peasant, an orphan. more text

derland

Q6.
List of your favorite web sites and why.

Lars: www.diebahn.de
www.lastminute.com
www.amazon.com
They provide me with useful information.

Q7.
What's wrong with most web sites?

Vassilios: There is no theoretical background behind them.

Lars: Too uninteresting, too big and usually useless.

About them:

Vassilios Alexiou, founder/conceptualist/programmer.
Lars Eberle, founder/conceptualist/designer.
Carsten Schneider, conceptualist/designer.

```
3 8 8 7 0 2 3 0 6 5 8 2 9 0 0 4 4 5 9 9 0 2 3 6 1 0 7 6 3 6 5 2
4 8 3 6 9 5 2 7 8 0 5 8 5 4 1 6 3 2 0 8 5 4 1 2 5 9 8 9 6 5 0 2
3 2 1 4 7 5 8 5 4 1 2 5 4 8 7 9 8 3 6 0 5 2 8 3 8 8 7 0 2 3 0 6
5 8 2 9 0 0 4 4 5 9 9 0 2 3 6 1 0 7 6 3 6 5 2 4 8 3 6 9 5 2 7 8
0 5 8 5 4 1 6 3 2 0 8 5 4 1 2 5 9 8 9 6 5 0 2 3 2 1 4 7 5 8 5 4
1 2 5 4 8 7 9 8 3 6 0 5 2 8 3 8 8 7 0 2 3 0 6 5 8 2 9 0 0 4 4 5
9 9 0 2 3 6 1 0 7 6 3 6 5 2 4 8 3 6 9 5 2 7 8 0 5 8 5 4 1 6 3 2
0 8 5 4 1 2 5 9 8 9 6 5 0 2 3 2 1 4 7 5 8 5 4 1 2 5 4 8 7 9 8 3
6 0 5 2 8 3 8 8 7 0 2 3 0 6 5 8 2 9 0 0 4 4 5 9 9 0 2 3 6 1 0 7
6 3 6 5 2 4 8 3 6 9 5 2 7 8 0 5 8 5 4 1 6 3 2 0 8 5 4 1 2 5 9 8
9 6 5 0 2 3 2 1 4 7 5 8 5 4 1 2 5 4 8 7 9 8 3 6 0 5 2 8 3 8 8 7
0 2 3 0 6 5 8 2 9 0 0 4 4 5 9 9 0 2 3 6 1 0 7 6 3 6 5 2 4 8 3 6
9 5 2 7 8 0 5 8 5 4 1 6 3 2 0 8 5 4 1 2 5 9 8 9 6 5 0 2 3 2 1 4
7 5 8 5 4 1 2 5 4 8 7 9 8 3 6 0 5 2 8 8 2 0 3 2 5 6 8 4 0 2 5 9
```

 Bitte jetzt Elektronische Illustration No. 05 oeffnen. (Mac-Version) *Please open electronic illustration no. 05 now. (Mac-version)*

planlos - strategies against coincidence © 1.1997 gunnar bauer

193

you want to watch something twice.

lounge

LOCATION
WWW.TENMEDIA.CO.UK

PORTFOLIO
ZURÜCK

PROJEKTE
TELEVISION EDUCATION NETWORK

DATE
JUN 99

SCREENSHOTS

BRIEF
RE-DESIGN OF THIS DATABASE DRIVEN EDUCATIONAL SITE AIMED AT SURVEYORS, ENGINEERS AND OTHER CORE PROFESSIONAL BRANCHES, INTEGRATING ONLINE TUTORIALS AND DOWNLOADABLE VIDEOS.

SOLUTION
A DESIGN BASED AROUND TECHNICAL DRAWINGS AND ILLUSTRATIONS FROM THE RENAISSANCE, THE VISUAL STYLE PROVIDES AN ADAPTABLE AND GRAPHICALLY CLEAN TEMPLATE FOR THE CONTENT, WHILE CORRESPONDING WITH THE INTELLECTUAL INTERESTS OF THE USERS.

INHALTE
LESSRAIN: PORTFOLIO NEU BELEGSCHAFT KONTAKT

WEBSEITE
FISCH

BILDSCHIRMSCHONER
VERTRAULICH

This is a preview of our contribution to the www.mycity.com.br project, the first world citywebdesign exhibition. It will be open to the public from December 21, 1999, until March 3, 2000 and will take place at Banco do Brasil's Cultural Center -one of the most important Brazilian art and cultural spaces in Rio.
Less Rain is representing London. www.lessrain.com/mycities

www.lorealpro.net

Vas Sloutchevsky is the creative director and vice president of Firstborn Multimedia in New York City. He co-founded Firstborn Multimedia in 1997, using Flash on a day-to-day basis since version 2 (he actually has a few spa files in his archives). He and his team have created high-profile digital designs for Calvin Klein, Redken, L'Oreal, The Beatles, Madonna and many other well-known names.

Vas comes from a family of artists. Being convinced that Flash is just another art form, he likes to characterize his work as "digital canvas, where technology merges with art." He is passionate about creating new navigation systems and aims to simplify the way data is presented to the user in elegant, stimulating interfaces. "There is nothing wrong with being too cerebral when it comes to designing an interface," says Vas.

His work for yigal-azrouel.com was recently awarded at the FlashT Film Festival in categories of Motion Graphics and Navigation, and MadonnaMusic.com in the Design category. Vas spoken at various events, including FlashForward, where his main topic was navigation design. Recently, he wrote a chapter and tutorial for the best-selling book "New Masters of Flash: The 2002 Annual."

RESEARCH
EDUCATION
FASHION
HAIRCOLOR

L'Oréal Profession introduces Majirel H Intensity Color Syste with two extra col rants added to the H Resistance molecule shades that are truer

1907 1929 1945 1952 1953 1974 1975 1994 1997 2000

MAJIBRANDS
COMPOSITE
CRESCENDO
DIACOLOR
OTHER

MAJIBLOND: LIGHTEST LIGHT BLONDING IN 1 STEP MAJIMECHES

The first no-ammonia, gentle highlighting cream that lightens up to 5 levels in 15 minutes. Used with Majimèche Highlightening Accelerator (available in .84 oz. packet and 10.15 oz. tub size), Majimèches is excellent for free-hand highlighting techniques.

MAJIBRANDS
COMPOSITE
CRESCENDO
DIACOLOR
OTHER

DIACOLOR GELEE

An ammonia-free, demi-permanent haircolor, Diacolor delivers beautiful color, brilliant shine and intense conditioning - courtesy of Ionene G – all in just 15 minutes. Whether enhancing the hair's natural color, blending away the gray or coloring non-pigmented hair, Diacolor imparts an absolutely dazzling shine. Salons may use Diacolor to refresh hair in between color services, accent highlights or

1 2 DULCIA AUTO PROTECTION 3 4 5 6

Gentle Perm System with Auto Protection

WORLD CLASS SALONS

DISTRIBUTORS

The World Class Color Millennium Salon Program is an innovative loyalty program designed to enable salons to share the L'Oréal Professionnel philosophy of excellence,

MICHIGAN

PENNSYLVANIA

DRAG RECTANGLE TO NAVIGATE MAP

NEBRASKA

ILLINOIS INDIANA

KANSAS MISSOURI

KENTUCKY

TENNESSEE

TONI+GUY

JACQUES DESSANGE

THE ZONE

THE ILO ACADEMY

SALON AKS

SOHO ACADEMY

THE ZONE ADVANCED TRAINING CENTER

OUR PHILOSOPHY:
We believe that focusing all of our energies on developing, promoting and enhancing the educational level of our trainers and staff is the greatest way to positively impact your learning experience. We will always maintain the highest levels of professional ethics and standards to create a new and lasting image for our industry.
OUR MISSION:

Advanced

THE ZONE

Training Center

About them:

Firstborn Multimedia

Founded:
1997

Place:
New York City, USA

Founders:
Michael Ferdman (President)
Mark Ferdman (Principal)
Vas Sloutchevsky (Vice President, Creative Director)

Web site:
www.firstbornmultimedia.com

Key web projects:
www.sergiorossi.com
www.beatles.com ('hey jude' feature)
www.lamrc.com (two on-line brochures)
www.madonnamusic.com
www.lorealpro.net
www.yigal-azrouel.com
www.bugedit.com

www.merzhase.de

Q1.
What is it about this site (merzhase.de) that makes it different from others?

The network "Merzhase" offers the possibility to present ideas to a broad range of people. It's not limited to design. The projects presented on merzhase have one thing in common: they are based on a conception. Work that deals with digital media does not necessarily have to be predominant on merzhase. No matter if one works as a garden designer or a novelist — everyone is very welcome. The design tries to connect pleasure and function.

Q2.
What made you come up with this approach? Inspiration?

Merzhase is inspired by classic book design as well as Japanese children's illustrations. The connection between "high" and "low" culture.

Q3.
If you were president of the World Wide Web what changes would you make?

Standardization of HTML and browser applications. Free Internet and bandwidth for all. No censorship.

Merzhase.Knowledge

Inventor Knowledge Exchange Map

➔ *Become a Merzhase Inventor...*

The network "Merzhase" offers the possibility to present your ideas to a broad range of people. "Merzhase" is a kind of portal site, which deals with innovations in design, art and technology. You should think about ways of presenting your work in a network like the World Wide Web, for example as a website or a PDF - file. "Merzhase" links its contents. Use "Merzhase" to share knowledge.

➔ Do you want to know more ?

Get Banner :

MERZHASE

Link to :

http://www.merzhase.de/

Merzhase.Inventor

Inventor Knowledge Exchange Map

➔ *Become a Merzhase Inventor...*

The "Inventor" section displays innovative solutions in design, art and technology. The projects presented there have one thing in common: they are based on a conception. Work that deals with digital media does not necessarily have to be predominant in this section. No matter if you work as a garden designer or a novelist - you are very welcome.

Visit also:

elephantcloud+
ndroid

Peter Scherbarth | Kaarungha. Das digitale Kartensystem

#001_Kaarungha is a digital cartography system that works with interactive, resolution - independent maps for on - and offline tasks. Kaarungha is a graphical user interface for spatially organized data. The complexity of information depends on the user's choice. Several map layers, which contain different thematical information, offer the possibility to connect various topics that seem to be non - related to each other at first glance. Use the shockwave demonstration to explore the fascinating world of the island of Kaarungha. Choose your configuration out of different map layers and use the navigator to discover most interesting details. The popular vector - technology "Flash" allows to scale the layers without loss of quality. Also use the command/control - keys in order to navigate through Kaarungha (Shockwave - Plug-In required).

Do you want to know more ?

➔ Download 500K Concept pdf file.
➔ Open Shockwave Demo.
➔ Write Mail to Inventor.

DOWNLOAD SHOCKWAVE PLAYER

Merzhase.Exchange

Inventor Knowledge Exchange Map

➔ *Become a Merzhase Inventor...*

The "Exchange" section is a kind of non - commercial "market of ideas". You can download self - created fonts as well as submit sound - composing mp 3 files, PDF novels or shockwave games. The idea behind an exchange is to give as well as to take. If you download anything you should also send something in order to share with other people.

EXPLORE THE INCREDIBLE STRANGE WORLD OF MERZHASE. YOU WILL NEED SHOCKWAVE.

Peter Scherbarth | som9x / Technikon

Soundtrack produced in 1998 using personal nineties samples.
Nor Music neither Hoerspiel. (File Size: 2,3 MB)
Soundtrack for Technikon. (File Size: 450 K)
Visit also
the forthcoming Technikon Website at
www.minko.net

Do you want to know more ?

➔ Listen: som9x.mp3
➔ Listen: technikon.mp3
➔ Write Mail to Inventor.

Zetuei | Zetuei Fonts

"Zetuei" means "the quickness that a shadow is not left."
Since a type and digital font were created, we have been losing our own words.
Whatever can we tell with the font that is equipped as a standard or is only choosen? The font that was produced and created by yourself can transmit your intention, idea and thought best.
Is it really important that the word is easy to read, understand and use?
Is it necessary to restrict words?
I say repeatedly,

Do you want to know more ?

➔ Go to Website
➔ Write Mail to Inventor.

Q4.
What is your best digital idea or project to date?

The visualization and the cartography of the digital world.

Q5.
Tell us about yourself: age, nationality, interests; anything that makes you different?

33, German, interested in everything.

About them:

Peter Scherbarth, the man behind
Merzhase is located in Berlin/Germany
and is a freelance designer.

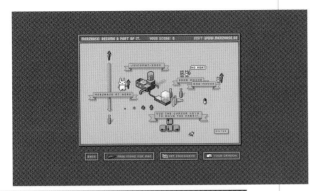

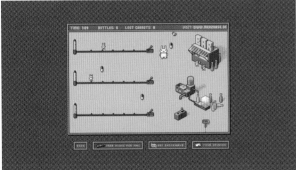

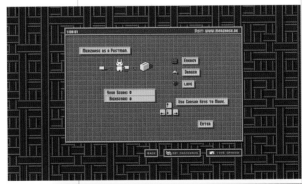

Q6.
List of your favorite web sites and why.

www.habbogroup.com
Innovative technology and nice graphics.

www.freshfroot.com
A good (!) example of an experimental interface
using flash.

www.google.com
The best search engine.

These sites use technology masterly to visualize
their concept.

Q7.
What's wrong with most web sites?

Content is dominated by form and technology.
Bad navigation concepts and no own ideas.
(Imitation, no usability, no visions.)

www.method.com

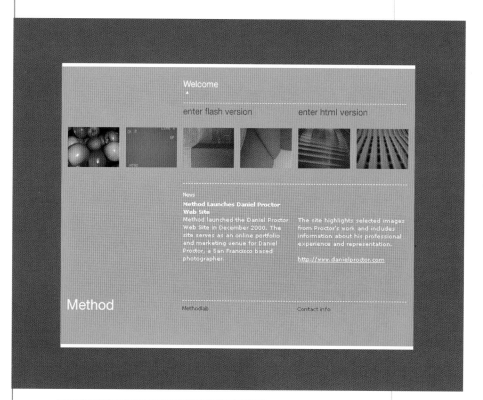

Q1.
What is it about this site (method.com) that makes it different from others?

Our goal was to create a Flash site without using common Flash clichés like "zooming" and other "cool" flash tricks. We wanted to use the technology for its smooth way of viewing content and to take advantage of Flash's total control of typographic elements.

In addition, the site is based on a rigid grid structure that is closer to that found in the print world rather than that of a traditional HTML web site.

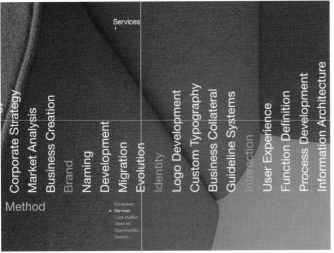

206

Q2.
What made you come up with this approach? Inspiration?

The look and feel of the interface comes from the desire to narrow the gap between print and web environments. Typographic rules that are typically more specific to print were applied to this site. The bleeding background picture is an element that was borrowed from a more editorial approach in design (i.e. magazines). The use of multiple background pictures gives the impression of a dynamic and visually rich experience.

Q3.
If you were president of the World Wide Web what changes would you make?

We would give free broadband access to the masses and open schools focused on development and improvement of the Internet. Secondarily, we would concentrate on a more effective way of negotiating content between various Internet-enabled devices.

Q4.
What is your best digital idea or project to date?

www.smashstatusquo.com
www.defytherules.com
www.theapt.com
www.moma.org/workspheres
www.method.com/methodlab/(3D Engine)

208

Q5.
Tell us about yourself: age, nationality, interests; anything that makes you different?

We are a multidisciplinary group of designers from all over the world (Germany, Sweden, Switzerland, Asia, UK, US, Australia). We're currently interested in raising the bar for design in the US.

Q6.
List of your favorite web sites and why.

www.typospace.com
www.module8.com
www.olipop.com
Because they all work here.

Q7.
What's wrong with most web sites?

Poor usability and navigation structures.

About them:

Key members:
Kevin Farnham, CEO
David Lipkin, COO
Patrick Newbery, Managing Partner
Mike Abbink, Creative Director SF
Olivier Chetelat, Creative Director NY (and lead designer of Method.com)

Awards:
(2) Print Magazine, Interaction 2000
Communication Arts, Interaction Annual 2000

www.mtv2.co.uk

Q1.
What is it about this site (mtv2.co.uk) that makes it different from others?

I think the fact that the site was one of the first that combined narrative elements, interactivity and 3D environmental representation made it particularly stand out. Accordingly, the design of the site, and recent technological advancements meant that it was created with it's own, innovative graphic language.

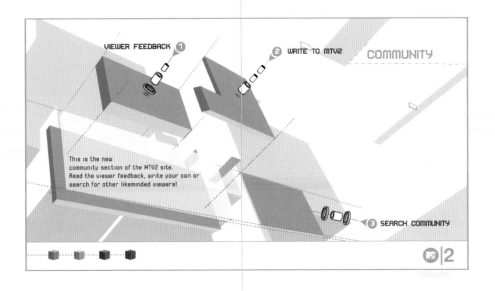

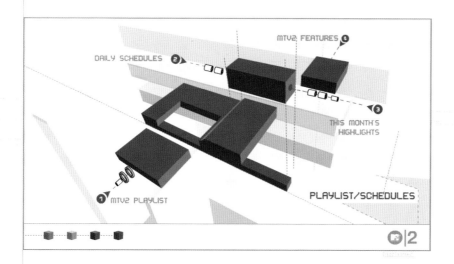

Q2.
What made you come up with this approach? Inspiration?

The approach was garnered from the initial concept of creating a community or environment that was representative of and encouraged communication amongst the target audience. Using these principles as a starting point, the design was led towards creating an artificial environment. Another principle or concept that we wanted to communicate was that the various elements or parts making up the web site were separate parts that together create the whole; the different sections are integral and a bit part of the MTV2 channel or brand as a whole. With this in mind, one of the most influential inspiration elements was a self-assembly kitchen unit instruction diagram that was found lying around the studio, which was subsequently used to inspire the graphic design.

To ensure that the environmental and narrative elements were explored and adequately expressed, we drew inspiration from a variety of sources including movies such as "Star Wars" and "Blade Runner" and computer games such as PacMan ands Super Mario Bros.

Q3.
If you were president of the World Wide Web what changes would you make?

A worldwide ban on the use of 45-degree angles and faux 'windows' interfaces. It's a cop out, encouraging bad design with lack of sensitivity to the solution.

Q4.
What is your best digital idea or project to date?

Thinking is always better than the realization. Everything works and there are no bugs when it only exists as an idea.

I can't tell you the best to date as I'm still working on it…

Q5.
Tell us about yourself: age, nationality, interests; anything that makes you different?

Me: Mickey. 27. English. Likes work/sleep. Dislikes work/sleep.

Q6.
List of your favorite web sites and why.

www.chem.ox.ac.uk/curecancer.html
Not exactly a web site, but absolutely the best thing on the Internet. Scientists have created a screensaver that when running, (i.e. in your downtime) tries and tests various molecular structuring that could or could not suggest a cure for cancer. Once findings are made the screensaver automatically sends the data back to the computational medical department at Oxford University. Using the Internet, literally thousands of people all around the world can be working together simultaneously in finding a cure for cancer without having to do anything.

www.thebreastcancersite.com
Again another charity or good causes web site, this time which donates free mammograms for every x number of user clicks. Once the 'donate' button is clicked, you are linked to an advertiser's page showing the companies which have sponsored and made the web site donations possible. Not beautiful, nothing special in terms of design, but putting advertising on the web (an otherwise fairly shit thing) to a very good use.

www.yugop.com
Entirely unoriginal selection, but Yugo's personal philosophy of creating beautifully crafted experiences is superbly executed. Seemingly without too much effort the site is full of precisely engineer and aesthetically beautiful material.

Q7.
What's wrong with most web sites?

I would argue that there isn't really much wrong with most web sites — without normal or unassuming web sites, there would be no room for the kind of special experiences that have been featured in the book. Where there is fault, it is generally in the form of inappropriate interactivity, graphic treatment that doesn't have anything to do with the content or concept, and banner advertising.

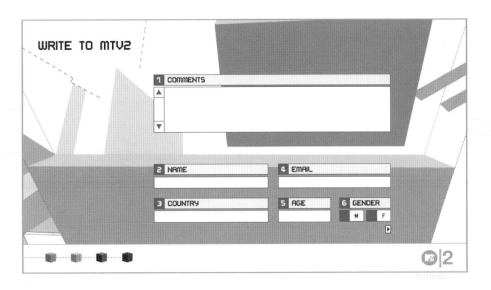

www.neeneenee.de

Q2.
What made you come up with this approach? Inspiration?

We started off with the site as a project we could work together on, since we developed a close friendship through the Internet. We both share a passion for the web and good design and we wanted others to be able to share in the experiences we had collected over time, so when we thought of creating something together, the focus of what the site should be about was fairly clear.

The site wasn't supposed to be static so another idea was to turn the collection of links into an archive which could expand over time. The inspiration for the site came from daily news sites like three.oh, k10k, surf station, DiK etc. and linkdup. What we did, was to combine the idea of daily inspiration with a large collection of links.

But there's also one important difference between us and the other sites: we never wanted to be part of the "link mafia" nor did we want to review sites, it's all about being fair and maintaining credibility: we link to the stuff we like, what we don't like doesn't get posted.

Q3.
If you were president of the World Wide Web what changes would you make?

The web is still lacking proper support for standards. The situation has been getting better recently but there is still a lot that can be done, so the answer would be: full support of css, xhtml, xml etc.

Q1.
What is it about this site (neeneenee.com) that makes it different from others?

Well, firstly (and what most people notice first) there's the color. Then, there's the fairly advanced level of scripting techniques that help create an interactive experience. And of course the main focus of the site, the link collection that is searchable. Getting the color just right was a challenge: how do you create a yellow site that is pleasing to the eye? Also there is the attention to detail, every pixel was checked over and over to get the placement just right.

What was important to us (and what the user doesn't notice, neither is he or she supposed to) was that the site should be easy to maintain; we created our own administration system from scratch that allows us to maintain the news-and-link-database quite easily.

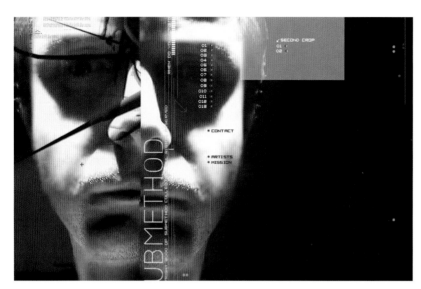

Q4.
What is your best digital idea or project to date?

Always those ideas that are floating in peoples' heads and probably will never see the light of day. Those quick and insane flashes you get.

Q5.
Tell us about yourself: age, nationality, interests; anything that makes you different?

OFF3NSIV3 is made up of two crazy Germans, Andre Stubbe (23) and Jan Gorman (19). Andre enjoys smoking dope and 3D. Jan's the same, only his passion next to bud is programming. We also try to stay in good shape, that's why we both practice ourselves in a strict regiment of nut sack lifting.

Q6.
List of your favorite web sites and why.

www.natzke.com
Most web sites are limited to either cool design or good technology, natzke is different and combines both in one delicious mix.

www.elixirstudio.com
Elixirstudio has been a long time favorite of both of us and it still is. Again there is this combination of good design and technology but also a nice variety in a style that seems timeless in its simplicity.

www.hotlixx.com
We only discovered this one recently and the great variety in style that Dan Schechter presents is awe inspiring, just tight!

Q7.
What's wrong with most web sites?

Fact number one: 99% of all web sites out there are just shit, there's no way around the fact that most people still don't have a clue about visual communication. The remaining 1% is a bag of mixed blessings; very few are really good, most are still pretty poor. Mostly it's a lack of attention to detail that spoils the experience in one way or the other.

www.netgraphic.ch

Q1.
What is it about this site (netgraphic.ch) that makes it different from others?

For us it's so important to have a unique site in the global web. The style of the site design is one part...the other also very important part, is the usability. Design and usability should work perfectly together. This is the only way in which to create a unique site experience for every single user.

Q2.
What made you come up with this approach? Inspiration?

Mhhh, not an easy question...I guess the original idea behind it could be found somewhere in my design brain. The first approach was to create a modern looking site, which has lots of possibilities and variations in design and content. So I created some basic sketches in Illustrator and made the finish in PS. For me it's very important that the design grows before finishing the site, cause some very nice and tricky ideas come while you are building the site.

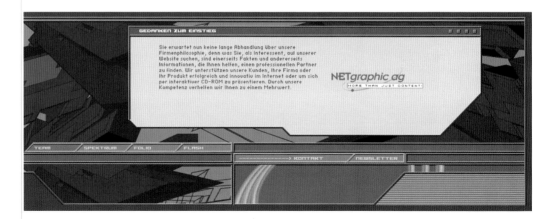

Q3.
If you were president of the World Wide Web what changes would you make?

For me one of the leading points is the performance. The bandwidth grows now but it's still too small for new media productions which I would like to see in the WWW.

Q4.
Tell us about yourself: age, nationality, interests; anything that makes you different?

O.K. name is Dani Tschanz, I am 29 now and I was born in Zürich (Switzerland). I live and work in this cool city. I love everything that comes with design, especially new media and print design, which are totally different than others. Also if it doesn't make that much sense but there are already too many ugly sites that make too much sense to me. I started my career as a print designer and as the WWW became more important also in Switzerland a working friend and myself thought of building a new media company... that's what we did four years ago. And since we started I always wanted to make unique designs for every kind of web site or CD-ROM or whatever comes on screen.

It's not always easy to sell such designs to the customers 'cause they would like to have it more mainstream...but I like the verbal fights and expressions that are necessary to bring the idea to an end.

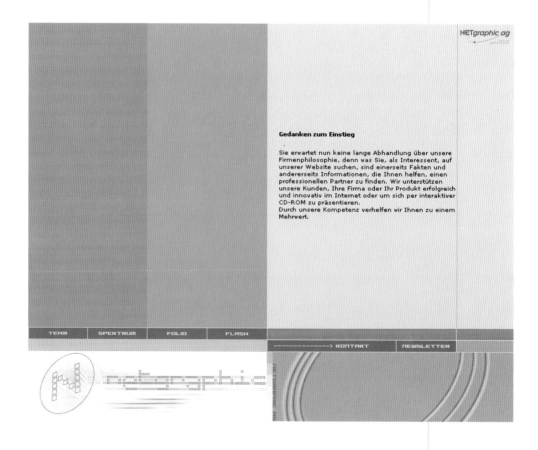

Q5.
List of your favorite web sites and why.

www.k10k.com
Best site to see some new and special new media stuff.

www.praystation.com
Always some really special and independent styles.

www.gmunk.com
What can I say...please rock on dude.

Q6.
What's wrong with most web sites?

From my view most web sites are too mainstream-blockhead thinking.
If you look at the portfolios from many companies (who create www-site
design) most of the site design looks common. Not a special look but
easy to build!!! And that's the point I can't understand. 'Cause if you
design a site for let's say a communication company, the site should not
look like a site for an office supply company. Every aspect is important
for the design, the colors, the pictures, the elements and of course the
animation styles.

About them:

Netgraphic ag is an Internet and new media agency located in the heart of Zürich, Switzerland. We are specialized in Internet and multimedia concepts, design in general and also Flash applications for the Internet/CD-ROM/ID-ROM/POS. Our skills and four years of practicing have made us one of the most sought after flash designers in Switzerland.

We are eight people right now, and happy with them, but still growing the two people handle all the work. Smile. Also, we won some awards for design and usability.

www.norm.to

NORM
INTRODUCTION.SCREEN
INTRODUCTION.BOOK
FONTS

Q1.
What is it about this site (norm.to) that makes it different from others?

There might be a difference in the intention of site, there's no commercial interest, but an interest in the media.

Q2.
What made you come up with this approach? Inspiration?

We wanted to do something very basic, very clear. A site with little choices to make
(not 100 blinking buttons).

Q3.
**If you were president of the World Wide Web what changes would
you make?**

No propositions.

Q4.
What is your best digital idea or project to date?

www.norm.to

Q5.
Tell us about yourself: age, nationality, interests; anything that makes you different?

Dimitri Bruni / 30 / Italian / + titanium / - qxp
Manuel Krebs / 31 / Swiss / + vectors / - qxp

Q6.
List of your favorite web sites and why.

www.vectorama.org
www.lineto.com
www.sbb.ch

Q7.
What's wrong with most web sites?

Too many things on them, information overloads.

www.alambic.qc.ca/nuworld

Q1.
What is it about this site (alambic.qc.ca/nuworld) that makes it different from others?

I think that at the time the basis of the site was created, it was in the midst of the whole "maximum" faze flying through the web design community — who could do the most fancy layered images possible. So to do something quite minimal at that time was very different. It quite amuses me at how it pre-empted the whole "gray and minimal" trend — but I feel that mine has even lived through that.

Q2.
What made you come up with this approach? Inspiration?

Basically, the prior site to this one was all over the place; pop up windows with set spaces, and haphazard type. After reading up a lot on Bauhaus, as well as getting interested in minimalism and modernism, I decided to tackle a new site that placed function first. So I really just planned out an easily navigated, easy to update, and fast loading site that dispensed with the tacked on eye candy.

Street Spirit 1Q '00
A poster based on the Radiohead song "Street Spirit (fade out). After buying the video "7 Television Commercials" and seeing the amazing film clip (in B+W and slow motion), the song was engrained in my head for days. So then I manifested it into a poster. Also I just had to find a use for the background image, I love that photo!

Masamune Shirow 4Q '99
A design project that required us to do a poster on an artist or designer. Mine was for famous manga artist Masamune Shirow, whose work includes Ghost in the Shell, Appleseed, Dominion, Orion, and his Intron Depot collections.
He has never shown his face in public, instead represents himself by the Octopus 'Takochu', just in case you were wondering about the image at the bottom right.

Macbeth 3Q '99
A plot diagram on Shakespeare's 'Macbeth' done for a school English project. Each scene is represented by a quote from that scene, and they are all split into two catagories. The top dark half contains the 'evil' scenes, whilst the white half holds the 'good' scenes.
Also of note is the Longitude and Latitude at the top right corner, aswell as the crossing lines - it's the exact location of Dunsinane Hill.

Q3.
If you were president of the World Wide Web what changes would you make?

Possibly the elimination of blinking text... that really gets my goat.

Q4.
Tell us about yourself: age, nationality, interests; anything that makes you different?

I'm currently 18 (change to 19 after September 4th 2001), and from Adelaide, South Australia.
My interests are pretty much music and design. I listen to a lot of music, of varying styles — from
alt-rock to brit-pop to J-pop, to electronica. I also play guitar. And design, well I don't need to
say any more. I can't really say specific things about what makes me different, as I like to think
I'm different in almost all regards. I pride myself on not fitting the mould. The stand out that
everyone picks is my love of gray. By some I've been given the title of "The Grey Incarnate,"
due to a complete wardrobe of gray clothes, and gray designs...etc.

Q5.
List of your favorite web sites and why.

My three favorites would probably be Kaliber10000, The Designers Republic and Shift. K10k has always been a great resource, and by virtue of almost constant updating, I know that each time I go there I'll find something fresh to explore. I've always been a big fan of DR, and their unique direction with their site is wonderful. Text-based navigation, minimal colors and imagery, and the excellent forum make it a must visit every few hours. Shift has also been important to me, as being a great fan of all things Japanese, I get to see a Japanese take on the design scene. Varied covers, and a great monthly e-zine are my main reasons for visiting.

Q6.
What's wrong with most web sites?

I think many people are trying to be too ambitious. Experimental interfaces and high bandwidth animations are all good and well, but I rarely stick around at such sites. Many forget that whilst they may be trying to do something unique and groundbreaking, that ease of use and usability should be the first priority.

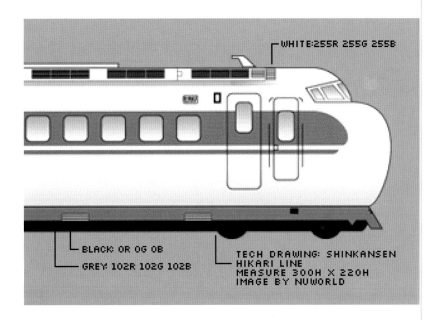

About them:

I'm a freelance designer, also studying Visual Communication full time at the University of South Australia. nu world has been the front of my freelancing for the past two years and within that time has been successful in creating a lot of interest and work for myself that otherwise would have been out of reach for a typical design student. nu world operates out of Adelaide, SA. Contact through the web site or email.

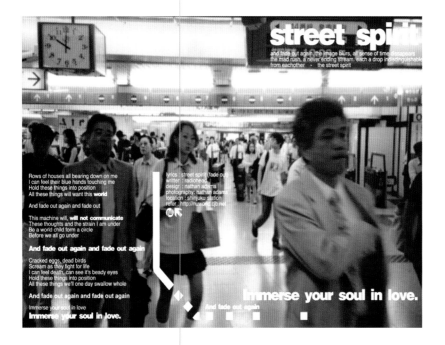

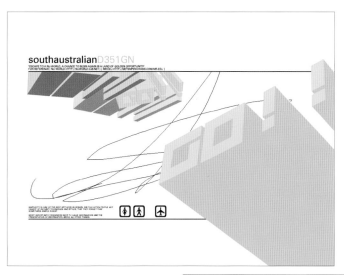

www.onedotzero.com

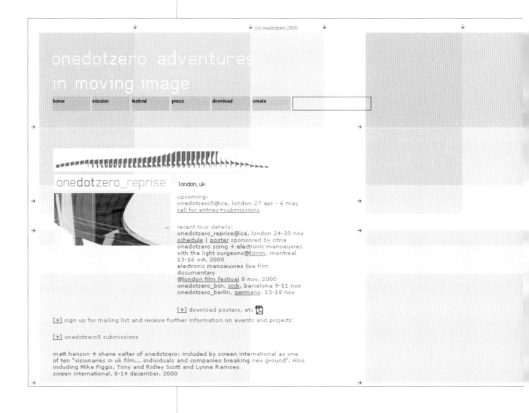

Q2.
What made you come up with this approach? Inspiration?

We get a lot of inspiration from maps, or any type of graphic that attempts to show a large amount of information on one plane and in doing so gives a rich overall picture of a space or system.

Q1.
What is it about this site (onedotzero.com) that makes it different from others?

We tried to create the site so that all the content was within one space so that rather than moving through a series of pages, you are zooming in and out of one plane, revealing or concealing more detail.

We wanted the layout of the site to convey information — the squares will fill in as we add more projects to the site, so you can see our body of work grow and your passage around the site is marked with 'breadcrumbs' lines that track where you've been.

Q3
What is your best digital idea or project to date?

As a body of work I think our work for the onedotzero film festival shows an interesting progression of ideas across a range of media (film, interactive, print).

Q4.
Tell us about yourself: age, nationality, interests; anything that makes you different?

Mark Hough, 29, UK
Philip O' Dwyer, 26, Irish

state design,
212c curtain house,
134-146 curtain road,
London ec2a 3ar
UK

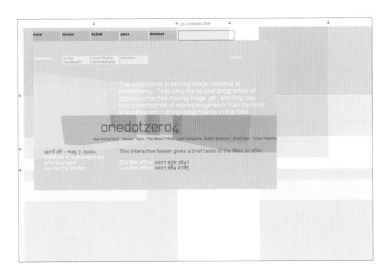

Q5.
List of your favorite web sites and why.

www.mid-tokyo.com
The incredible depth of content, and the imagination and intelligence with which it is presented make this my favorite site at the moment.

www.roadthinker.com
There are lots of on-line diaries. This seems like the perfect application for the web log.

www.plasticbag.de

Q1.
What is it about this site (plasticbag.de) that makes it different from others?

It was not made to please the mass audience; it does not make use of trendy technologies and graphic styles.

Q2.
What made you come up with this approach? Inspiration?

Josef Muller-Brockmann, MC Escher, Emil Ruder, Willi Kunz, Mike Cina, eboy, quickhoney. It evolved. I like creating complex things out of simple and plain elements.

Q3.
If you were president of the World Wide Web what changes would you make?

True freedom of speech, stop commercializing the web and push it into its original direction — information exchange, enforcing standards for Internet protocols/languages/scripts.

Q4.
What is your best digital idea or project to date?

plasticbag.de

Q5.
Tell us about yourself: age, nationality, interests; anything that makes you different?

24, German, girlfriend, design, code, ascii, warp, schematic, skam, kranky, hefty, blue note, island records, ninja tunes, mo wax, rawkus, console, arcade, skate, snowboard, graffiti, movies, music, Berlin, London, rizla, shirts, stickers, sex, drugs, PowerBooks...

Q6.
List of your favorite web sites and why.

jodi.org
Because the site is so unique.

dextro.org
Because the site is so unique.

e13.com
Because the site is so unique.

Q7.
What's wrong with most web sites?

Not focused on the needs of the users, download heavy, over usage of flash, weak navigation/information architecture...

Wiederholung
Repetition
Répétition
Repetición
Ripetizione
Herhaling

About them:

Fork has established itself as one of the top creative shops for high profile corporate clients such as Daimler-Chrysler, Gruner + Jahr, Lufthansa Systems Network, Nivea and the American MTV. The work of the studio is featured in books, magazines and museums in the United States, Asia and throughout Europe. We are currently active in Hamburg and Berlin. A third office in Brooklyn, New York is reserved for employees, inspiration and soon, its own team.

Awards:
Clio Awards Interactive: silver
Art Directors Club New York: merit award
One Show Interactive: silver
Cannes Cyberlions: finalist
I.D. Magazine Interactive: bronze
The Web Crit (critique's int. interactive design competition)
Three fork web sites are part of the SFMOMA collection

Best-known projects:
nivea.de
nivea-baby.de
saturn.de
lab01.de
lhsysnet.com
receiver.mannesmann.de
themoreyouknow.com
urbanrecords.de
8x4.de
ersteliebefilm.de
popinger.com

www.potatoland.org

Q1.
What is it about this site (potatoland.org) that makes it different from others?

At Potatoland.org the user can play with the artwork. From the very first screen, the site reacts to the user's input. In some pieces, the screen is blank until the user takes an action, clicks or moves their mouse. The user plays a role in how these artworks unfold.

Q2.
What made you come up with this approach? Inspiration?

I have worked in software development for more than a decade, and have always enjoyed making tools: software that enables the user to work creatively within a software environment. In potatoland.org I apply the ideas of software tools to the visual aesthetic of painting. The software creates an environment where the viewer can shape an aesthetic experience by 'using' the artwork. The art is an interface to an aesthetic experience.

Q3.
If you were president of the World Wide Web what changes would you make?

I would pass a law banning the office of the president of the World Wide Web, then arrange to have myself assassinated in a bloody coup led by pirate hackers.

Q4.
What is your best digital idea or project to date?

I enjoy Feed (http://feed.projects.sfmoma.org), a project commissioned by the San Francisco Museum of Modern Art. Like other projects I've done (Shredder and Digital Landfill) Feed appropriates text, images and code from the web to use as raw material for its own aesthetic purpose. Feed unravels the web. It breaks html pages and images down into a stream of letters and pixels, turning web 'content' into a stream of numeric data. Feed then plots, graphs, charts and averages that data, as if searching for a new meaning in the disembodied thread that once was a web page.

I like the piece because it shows the unreality of the web. The web is a massive collection of files that can be displayed any way we choose. Normally the browser organizes these files into a sane and meaningful presentation: rows of text with relevant images placed carefully nearby. When we treat the bytes in these files as numbers, then graph and chart those values on a screen, a surprising beauty and symmetry emerges, often revealing patterns within the data that were not visible when the data was presented in a way that makes sense.

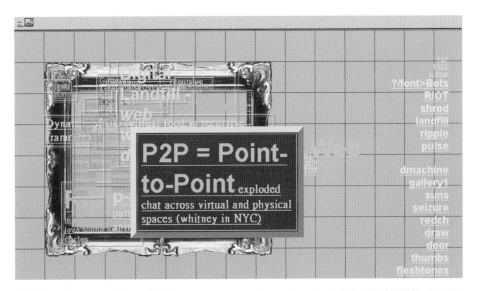

Q5.
Tell us about yourself: age, nationality, interests; anything that makes you different?

Age: 39
Nationality: USA
Interests: net art
What makes me different: Besides my activities as a net artist I am profoundly average.

Q6.
List of your favorite web sites and why.

I haven't surfed the web since 1995, so it's hard to say what my favorites sites are. I have been inspired by jodi.org, and turux.org. Both treat the web page as a space for a unique form of art.

Q7.
What's wrong with most web sites?

I don't think of sites as right or wrong. The boring ones still look good shredded (see potatoland.org/shredder).

About them:

Potatoland.org is the on-line art studio of Mark Napier, net artist since 1995. Napier was a painter and earned a living as a software developer for the finance industry in New York City. In '95 he started making art for the web, creating The Distorted Barbie, a visual parody of the famous pop culture icon. Mattel, the creators of the Barbie doll, were less than thrilled with Napier's Photoshop distortions of their product, and attempted to force the site off the web.

In '98 Napier started Potatoland.org where he has released many net art projects including the Digital Landfill (potatoland.org/landfill), the Shredder(potatoland.org/shredder), and p-Soup (potatoland.org/p-soup).

His net art has been awarded honorable mention at Arts Electronica, and received prizes from the ASCII Digital Art Festival, the Fraunhofer Society. Napier has been commissioned to produce works for the San Francisco MOMA, the Whitney Museum, and the Guggenheim Museum. His work has been shown in galleries and new media festivals internationally and has been reviewed in the "New York Times," "ArtByte," "ArtForum," and "ArtNews."

www.praystation.com

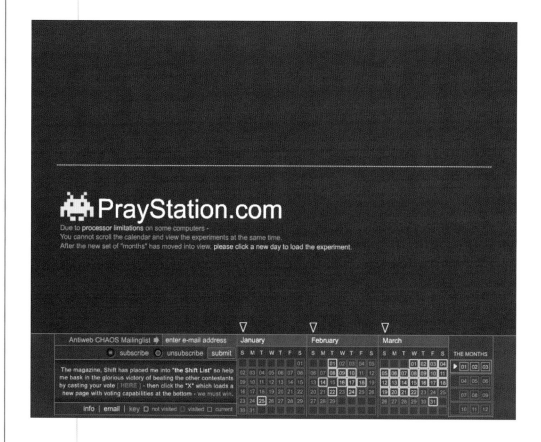

PrayStation and Presstube

Subject 01. Joshua Davis - United States

Subject 02. James Patterson - Canada

Location of Violation : New York City, New York

Topics of Discussion : Chaos Theory, Fractal Mathematics, Signals, Systems, Technology, Animation, Mentalities, Anomalies, Physics, Interaction Design, March Core Environment Adaptations - with Veg. Lasagne and Penne.

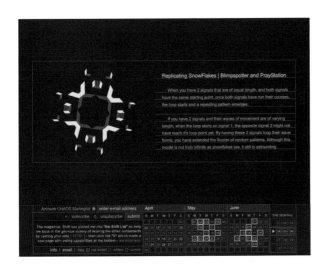

Replicating SnowFlakes | Blimpspotter and PrayStation

When you have 2 signals that are of equal length, and both signals have the same starting point, once both signals have run their courses, the loop starts and a repeating pattern emerges.

If you have 2 signals and their waves of movement are of varying length, when the loop starts on signal 1, the opposite signal 2 might not have reach it's loop point yet. By having these 2 signals loop their wave forms, you have extended the illusion of random patterns. Although this model is not truly infinite as snowflakes are, it still is astounding.

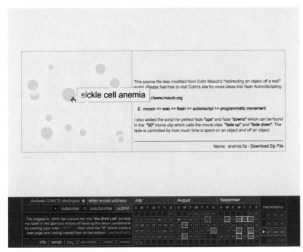

sickle cell anemia

This source file was modified from Colin Moock's "redirecting an object off a wall" script. Please feel free to visit Colin's site for more ideas into flash ActionScripting.

//www.moock.org

2. moock >> web >> flash >> actionscript >> programmatic movement

I also added the script for perfect fade "ups" and fade "downs" which can be found in the "00" movie clip which calls the movie clips "fade up" and "fade down". The fade is controlled by how much time is spent on an object and off an object.

Name: anemia.fla - Download Zip File

M H Z R O I E

www.presstube.com

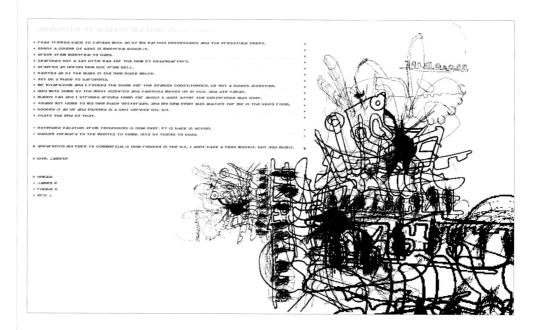

Q1.
What is it about this site (presstube.com) that makes it different from others?

I care about drawing and how that relates to concept, emotion, and the examination of systems.
Flash is just a tool for me, and the Internet is just a venue.

Q2.
What made you come up with this approach? Inspiration?

I loved playing as a kid; just sitting for hours building things and creating worlds for myself. Multimedia has become my new way to play and create. I have been inspired by too many people to list. A couple of keystone inspirations would be drawings from: Paul Klee / Egon Shiele / Mondrian / Jenny Saville / Sarah Sze.

Animation: Norman McLaren

Code systems: Josh Davis / Amit Pitaru

Q3.
If you were president of the World Wide Web what changes would you make?

I don't know. Maybe I would get rid of Netscape and enforce a strict universal standard for code and syntax on the web. Probably nothing though. I am ok with how the web is developing right now.

Q4.
What is your best digital idea or project to date?

The project I did with Amit Pitaru, www.pitaru.com, for the codex 3 CD-ROM. It is called "Insert Silence : configuration 1." Coming soon. www.codexseries.com. That is my favorite so far, but who knows what will happen between now and when this book comes out. We are working together on a new project right now actually. Look out for a domain that is between pitaru and presstube sometime in the near future. www.insertsilence.com. It will house joint projects.

Q5.
Tell us about yourself: age, nationality, interests; anything that makes you different?

I am 21, I am a British born-Canadian. Not sure if any of my interests make me different. Maybe my interest in working almost 24 hours a day.

Q6.
List of your favorite web sites and why.

www.padk-rad.com
Because I have been going there for two years and there is always more for me to hear. krad rocks!

www.designgraphik.com
Because it has been taken so far that it has become something completely new. It seems to be derived from a look that existed somewhere else but has been made completely unique and surpassed its original source of inspiration. This site never ceases to amaze. Each time it is updated it raises the bar.

www.0003.org
Because it has genuine emotional impact if you explore. It is personal and honest, and has rock solid concept and delivery together, which is unusual on the web.

Q7.
What's wrong with most web sites?

They are a veneer, instead of the rich world they could be, and that I would want to experience.

About them:

Presstube is: James Paterson, Robbie Cameron, and Eric Jensen.
Our office moves as much as we do; Presstube is a roaming
operation for now. It may settle down geographically later on.

[hit SPACE to clear_ _ _ _ _hit ENTER to advance>>]
[>>>drawings with robbie_ _ _ _ _ _ _coming soon.]

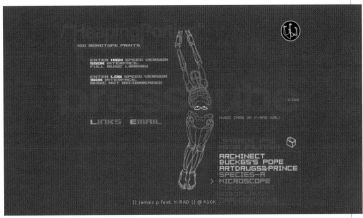

140 MONOTYPE PRINTS

ENTER HIGH SPEED VERSION
550K INTERFACE
FULL MUSIC LIBRARY

ENTER LOW SPEED VERSION
160K INTERFACE
MUSIC NOT RECOMMENDED

LINKS EMAIL

MUSIC CARE OF K-RAD (URL)

ARCHINECT
BUCK65'S POPE
ARTDRUGS&PRINCE
SPECIES-A
> MICROSCOPE

|| james p feat. K-RAD || @ K10K

MENU
MAX DUPLICATION>> 10 ENTER

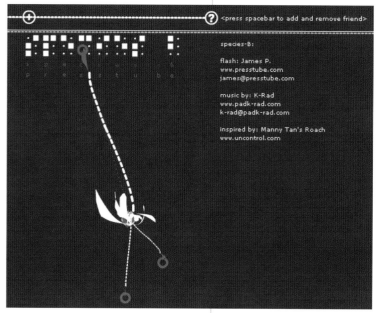

use left arrow key to delete < ? > use right arrow key to build

DIG DEEP

www.shift.jp.org

Q1.
What is it about this site (shift.jp.org) that makes it different from others?

Our role as an originator being a point connects between creativity and creativity.

Q2.
What made you come up with this approach? Inspiration?

When we started it in 1996, we wanted to do with a magazine style as a system to reach information, not as a large search engine. Hopefully, it will be one of the waterways. It was a natural step to have focused on creativity. Including myself, there was a necessity to do that. Inspiration comes from everything happening around us including on the web.

SHIFt

english ●
japanese ●

SHIFT 050 MADE IN JAPAN

GASBOOK9

GASBOOK9
Naohiro Ukawa, Nick Panish, Jeremy Hollister, Hexstatic, Prince Tongha, The Designers Republic, Alex + Martin, Katsuki Tanaka, Dextro, Geoff McFetridge, Namaiki, Yutanpo Shirane

GASBOOK8
Acne International, c404, Dainippon Type Organization, Geoff McFetridge, H5, Intro, Katsuki Tanaka, Nendo, Run Wrake, Shynola, Sountain + Mono*crafts, Syd Garon + Eric Henry, The Designers Republic, Tomato, Yutanpo Shirane

GASBOOK7
Ages 5&up, Day-Dream, Delaware, Delta, Dextro, Dvicegirls, Dylan Kendle, Hexstatic, Hikaru Koike, Enlightenment, Ichiro Higashizumi, Imaginary Forces, Inflate, Isabel Truniger, Me

JANUARY 2001 SHIFT VOL.50 ◆ *Contents* SF

SHIFT 038 | MADE IN JAPAN

INFO-WORLD

Direct borderground source from the edge of the world

san francisco
nyc
london
paris
hamburg
hongkong
tokyo

SHIFT 050 | MADE IN JAPAN

TOKYO CUTIE GIRLS

About them:

Shift Production Ltd. is the sole agency for a publisher of E'Zine SHIFT, on-line select shop and indices on-line label, which distributes a number of Japanese garage fonts, CD-ROM titles such as Fontrom, a graphic design, book IMG SRC100 etc. It also functions as an agency that runs SHIFT FACTORY and cooperates with a CD-ROM Magazine GASBOOK and a magazine DESIGN PLEX, exploring the field of new media.

Shift Magazine has been featured in many worldwide design magazines such as *ID*, *Creative Review*, *IdN*, to name a few.

Q3.
If you were president of the World Wide Web what changes would you make?

I'd provide free cyber spaces for poor countries.

Q6.
List of your favorite web sites and why.

Google: feeling good.

Q7.
What's wrong with most web sites?

The wrongness and goodness are always on the same coin. There's something good even in what looks wrong.

Q4.
What is your best digital idea or project to date?

Digital transmission of materials. It would change the world.

Q5.
Tell us about yourself: age, nationality, interests; anything that makes you different?

There's no one who is completely the same as you, unless it's a clone.

SHIFT FACTORY

"ON-LINE SERVICE ARCHIVE FOR SHIFT AS ON-LINE LABEL"

WEAR:
01. Shift Quote T-shirt [BODY:WHITE, SIZE:S/L]
Design: Paradise Graphics.
02. Shift 3D Logo T-shirt [BODY:WHITE, SIZE:S/L]
Design: Matt Owens.
03. Shift Girl T-shirt [BODY:WHITE, SIZE:S]
Illustration: Buen Ban.
04. Shift Quote Long-sleeved [BODY:WHITE, SIZE:M/L]
Design: Paradise Graphics.
05. Shift-Enemyco Long-sleeved [BODY:BLACK, SIZE:M/L]
Design: Enemyco.
06. Shift Logo Long-sleeved [BODY:GRAY, SIZE:M/L] NEW!
Design: Paradise Graphics.

FONT:
Fonts available for Macintosh&Windows
F=Freeware / S=Shareware
A=Alphabet / K=Katakana / H=Hiragana

FONT VIEWER PT1, PT2, PT3
[Click above for quick viewing with flash]

04. Nippon Bold 2.0 [S/K]
13. Helveticana Bold [S/K]
14. Squaretype 2.0 [S/A,K]
17. Fat-Ultra 2.0 [S/A,K]
25. Animals [F/SILHOUETTE]
33. Leaves [S/A,K]
48. Child Blocks [F/A]
70. Sebastian [S/A,K,H] NEW!
Product: Extra Designs.

07. Note Font [S/H]
23. Throw, Underthrow [S/A]
24. Musasabi [S/A]
Product: Hideki Inaba.

11. Circular9 [F/A]
12. Lemon2.0 [S/A,K]
28. Shammim [S/K]
29. Sprite Bold [S/A,K]
Product: G System.

Fontrom#1

www.skim.com

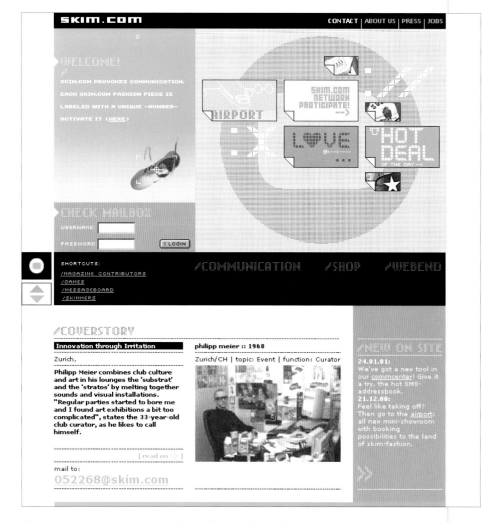

skim.com is a growing company, originally born from a task force of eleven creative individuals: designers, marketeers, computer wizards and the Freitag brothers — makers of the Freitag recycled bags — who all came together to turn the vision of skim.com into reality.

From a loose network of people, a company developed. After working with our own money to develop Stage One of the project, we were able to raise venture capital. skim.com first went on-line in November 1999. Our studios are located in Zurich, Switzerland.

Communicating Products – Productive Communication
The basic concept of skim.com is to integrate on-line communication with street communication by tagging all products, art and text with numbered codes. These numbered codes are email addresses on skim.com. We do this to link people together worldwide, to build an open network for participatants both off-line and on-line.

Vision
skim.com gets involved in various projects which all share the same vision:

• Integrating the digital with the physical world
• Integrating commercial goals with cultural goals
• Providing a platform for real and virtual interaction
• Providing cutting edge concepts, products and services to people who appreciate them

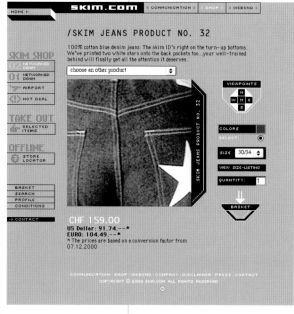

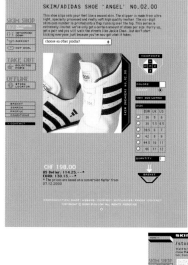

/print

<Issue #01>

<Switzerland/ZRH>

<Netropolis/NET>

<The Netherlands/AMS>

<USA/SFO>

<USA/NYC>

<Japan/NRT>

<Issue #02>

<USA/LAX>

<India/BOM>

<Austria/VIE>

<Netropolis/NET>

<Bosnia/SJJ>

<Israel/TLV>

order now_2

#2 / topic:numbers

This second issue assembles contributions to the topic 'numbers' from three continents and five cities. It's a platform for people with a mission ? to present a snapshot of their local cultural dynamic to a global audience. The resulting diversity is intended. It depends on the cultural environment the contributors live in. We search for new ways to provoke and to communicate in real and virtual space. We want the readers to get in contact with the contributors. Therefore, to every contributor and to every reader we allocate individual numbers, serving as skim.com email-addresses. The contributor's ones can be found on every page. Your own skim.com number is printed on the plaster enclosed with the magazine. Our proposal: Plasters are cool fashion accessories - wear it and provoke interaction.

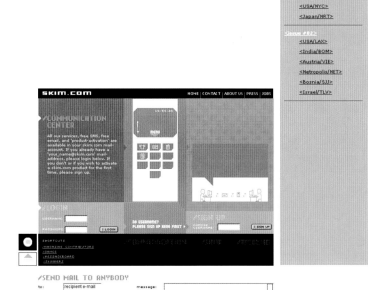

SKIM.COM HOME | CONTACT | ABOUT US | PRESS | JOBS

/COMMUNICATION CENTER

All our services, free SMS, free email, and 'product-activation' are available in your skim.com mail-account. If you already have a 'your_name@skim.com' mail-address, please login below. If you don't or if you wish to activate a skim.com product for the first time, please sign up.

menu

/LOGIN NO USERNAME? /SIGN UP
USERNAME PLEASE SIGN UP HERE FIRST CHOOSE USERNAME
PASSWORD > SIGN UP
> LOGIN

SHORTCUTS
/MAGAZINE CONTRIBUTORS
/COMICS
/MEZZASOARD
/FLIMMER.T

/SEND MAIL TO ANYBODY

to: recipient e-mail message:

from: your e-mail

subject:

> SEND

NUMBERS PLAY ▶

1 2 3 4 5 6 7 8 9 0

Hit «PLAY»

Can you work out
the six digit number?

Get it right,
go onto next level.

LEVEL 1

SIX NUMBERS
?????? GO

www.soda.co.uk

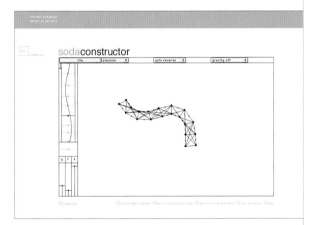

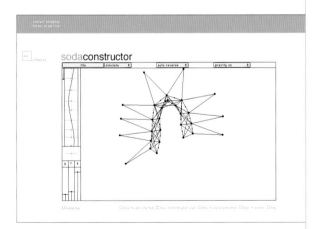

Q1.
What is it about this site (soda.co.uk) that makes it different from others?

I think the design of our site can be described as restrained. It is direct and immediate, without graphic overkill. The one feature that offers an element of play, is the swirling java navigation piece. This makes sure the content of the site stands out, attention is not diverted elsewhere.

Q2.
What made you come up with this approach? Inspiration?

I think it reflects the character of people working here — it reflects the way we think.

Q3.
If you were president of the World Wide Web what changes would you make?

A robust system for consistent delivery. Also, more emphasis on information design. Edward Tufte's books set a good example. The most important thing about the web is content and ideas — no amount of flashy design features can cover up for a site that has nothing to offer.

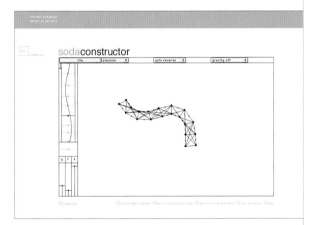

Q4.
What is your best digital idea or project to date?

"Eclipse" an interactive narrative; a group project, done
while studying at Middlesex University.

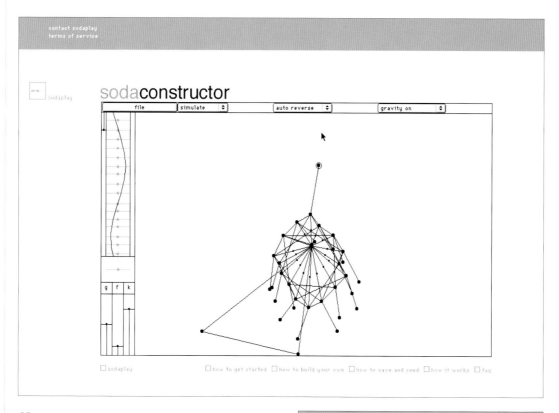

Q5.
**Tell us about yourself: age, nationality, interests; anything that
makes you different?**

I am a 29-year-old Norwegian female. I initially moved to England to
do a BA in Graphic Design. Later I did an MA in Design for Interactive
Media, at Middlesex University. Finally, I decided to stay in London to
work. I am now a Graphic Designer at Soda Creative Technologies.

What I am most interested in, outside work, are narratives and stories.
I have always been a big consumer of books, films and theatre, and
would like to investigate how to use this medium to tell stories.

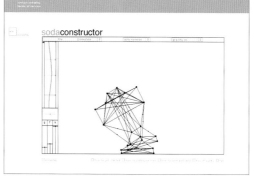

Q6.
List of your favorite web sites and why.

I like these sites because they all give you rewarding experiences, and without asking anything in return.

www.vectorpark.com
This site presents you with two puzzles, and I keep coming back in the hope of finding new ones. In the first puzzle you understand that finding the balance will help you succeed. The second is a more surreal environment with a lot of hidden areas. You must unravel a series of secrets to gain access to these areas.

www.demian5.com
A charming story about a man and a camel. The attraction, for me, is the illustrations, combined with use of simple technology. It demonstrates that it is not necessary to know a lot of scripting, or use software that requires all kinds of plugging to create engaging content.

www.jotto.com/bubblesoap/bubblesoap.html
I really like this site, and keep coming back to it. It is a playground with a lot of room for exploration, and is populated with Jotto's adorable characters.

Q7.
What's wrong with most web sites?

When you browse the web it seems that, currently, everyone just wants to sell things. The commercial aspect of the web doesn't neccesarily make it bad. I just think it would make it much more interesting if the tendency would be to create rather than sell.

www.statedesign.com

ZOOM OUT_ STAFF@STATEDESIGN.COM BREADCRUMBS (C) STATE 2000

NEW 24.03.02

COLDPLAY
WEBSITE_

The cover of Coldplay's album 'Parachutes' We took this familiar image and turned it into
features an image of a glowing, spinning an engaging digital object that functions as
globe. This photograph provided a starting a navigation device for the site.
point in the design of the band's website.

VISIT COLDPLAY.COM

STATE

ZOOM OUT... STAFF@STATEDESIGN.COM BREADCRUMBS × (C) STATE 2000

**RELOAD
INTERNET DESIGN BOOK...**

HEXSTA1

Reload charts the progress in the search for a new visual language for the web.

The book consists of a selection of 30+ innovative (in visual or technical terms) websites. Visual documentation of the sites is supplemented with views and predictions from the sites designers.

The raw material for the book was a list of urls, together with the answers to four questions from all the sites designers, and an introduction.

→

**HEXSTATIC
WEBSITE / CDROM**

Hexstatic's debut album Rewind includes a cdrom containing videos for each track on the album and a series of remix toys.

State designed an interface to link all these elements together. Inspired by the classic Atari game Battlezone, the user surveys a 3d wireframe landscape filled with objects to be explored, that lead to a video or a toy.

VISIT HEXSTATIC.CO.UK

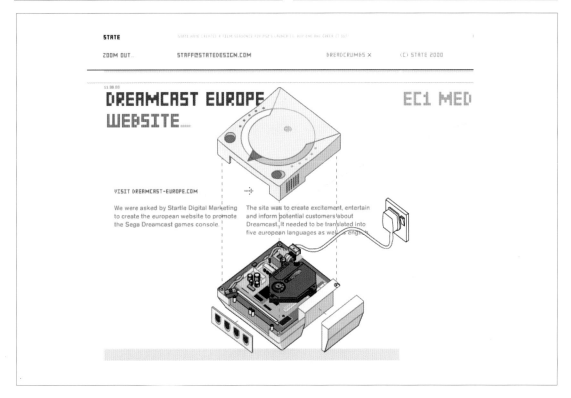

STATE

ZOOM OUT... STAFF@STATEDESIGN.COM BREADCRUMBS × (C) STATE 2000

11.08.00

**DREAMCAST EUROPE
WEBSITE...**

EC1 MED

VISIT DREAMCAST-EUROPE.COM

We were asked by Startle Digital Marketing to create the european website to promote the Sega Dreamcast games console.

The site was to create excitement, entertain and inform potential customers about Dreamcast. It needed to be translated into five european languages as well as english.

www.stampete.de

stampete.de v20 is still in development.
wanna see **v19?** click **here.**

thanks for the nice mails. i love you all!
check out my splashpage over at <u>deformat</u>!

Q1.
What is it about this site (stampete.de) that makes it different from others?

The difference is that I designed it in a way I can change the complete background
(which is in fact the complete design) without having to modify the content.
Somehow it's the reverse of the usual way to change web sites.

Q2.
What made you come up with this approach? Inspiration?

I wanted to be flexible towards the look of the site. New ideas should be able to be uploaded as fast as possible and visitors should experience some alternation.

Q3.
If you were president of the World Wide Web what changes would you make?

I'd change nothing. The web should stay as it is. Users decide which technologies break through and which don't. They define the standards. Users for president.

Q4.
What is your best digital idea or project to date?

The best project on my actual web site is in my humble opinion "lucky bastard." The best thing I've made so far is the cover of the mental tearing after 9 CD album "white tiger rodeo."

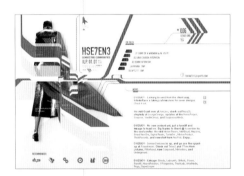

Q5.
Tell us about yourself: age, nationality, interests; anything that makes you different?

I was born on 6/8/75 in Neunkirchen, Germany. I love music (guitar noise, alternative, post-rock...and play bad guitar. I don't like dogs. I like 3D Shooters and make very little sports (NO sports) In RL I hang around with my friends and go to concerts.

About them:

I'm working for an IT services company in Neunkirchen called am_it Andreas Mayer IT - Services. It consists of three to five members so far. Its owner Andreas Mayer is one of my closest friends. We built several regionally well-known web sites for regional companies and institutions.

Q6.
List of your favorite web sites and why.

Aaarrghgh, there are so many:

sodaplay.com
Interaction rules! Technically very strong!

ikda.co.uk
Due to the simian series. Brilliant!

evilpupil.com
'Cause I get scared like in a horror movie.

Q7.
What's wrong with most web sites?

They take too long to load.

www.stilidesign.ch

Q1.
What is it about this site (stilidesign.ch) that makes it different from others?

The navigation surface represents a crucial part of the design as a whole. Pictures are dealt separately. If the user wants to see more, he or she is guided through a pop-up window which is reduced for attractive usability.

Q2.
What made you come up with this approach? Inspiration?

Circles: LP's, Singles, Disks.

Q3.
**If you were president of the World Wide Web what changes
would you make?**

I would suggest technical standards to be handled more strictly.
Not having to deal with all kinds of browsers would allow a design
to be more efficient and precise.

Q4.
What is your best digital idea or project to date?

Get dubbed, www.dubsearch.ch

Q5.
Tell us about yourself: age, nationality, interests; anything that makes you different?

Martin Stillhart, 31, Zurich, Switzerland. Favorite ice cream: Walnut. Winner of the wobbling ears contest 1999.

Q6.
List of your favorite web sites and why.

www.vectorama.org
Technically and visually smashing.

www.shift.jp.org
Up-to-date information on design.

www.sbb.ch
Where to go and when.

Q7.
What's wrong with most web sites?

Often it seems that design ideas and usability aren't paid equal attention.

ausserhaus
20 Minuten
Bankiervereinigung
Belleville AG
Coca-Cola Beverages AG
ETH Zürich
Expo.02
Freitag Ltd.
Hewlett Packard
HGKZ
Hochparterre
Kanton Zürich
Kapers
Manesse Verlag

Randle Siddeley Associates
Royal Caribbean
Schweizer Heimatschutz
Spitex
Swissmem
TA-Media
UBS
Verein Theater Hora
Verlag Ricco Bilger
Vertec Ltd
V-Zug AG
Yoelki International AG
Zürcher AIDS-Hilfe
skim.com

PROJECTS WHO CLIENTS MAIL bureau

www.substrat.ch

Q1.
What is it about this site (substrat.ch) that makes it different from others?

What is it about your site that makes it different to others? The screen design is reduced to the minimum. There are no logos, no colors, no banners. The navigation is not quite obvious; you have to take your time to make your way through, as in the real life...

The site is not finished. It is under permanent construction and will change its face from time to time, which is part of the concept.

Q2.
What made you come up with this approach? Inspiration?

The biggest inspiration I got of the abstract lounge itself, which is located in Zurich. It is a non-commercial platform for experimental electronic music and video art. I tried to bring the ambiance of the lounge to the net, which worked out quite difficult, cause you cannot use and all your senses.

Q3.
If you were president of the World Wide Web what changes would you make?

To make it possible for everyone to go on-line. Separate e-business from the rest of the web.

286

Q4.
What is your best digital idea or project to date?

There are no bests, every project stands for itself, each has its own priorities.

Q5.
Tell us about yourself: age, nationality, interests; anything that makes you different?

I am 32 years old, living and working in Zurich, Switzerland. There are no special interests that make me different.

Q6.
List of your favorite web sites and why.

Favorite on the net is a very-short-time, often changing.

www.indymedia.ch
For its political information and horizontal structures.

www.soulbath.com (hi-res.com)
For its great interactive design.

www.grr1999.com
For its charming style.

Q7.
What's wrong with most web sites?

They are too commercial, too boring, and they all look the
same. Business as usual, like a mirror of the real life. There is
no content behind them. They are not trying to use a new
medium in a new way.

www.theapt.com

Q2. What made you come up with this approach? Inspiration?

Kitchen

THE APARTMENT

ToGo

ToDo
What
Where

Back

Audio

Joe milk/Joe cream
Alfredo Häberli, 2000

These are only two of a wide
collection of jugs, decanters and milk
jugs in clear glass. Made in Italy,
they are extremely elegant on any
table and are sure to answer the
question: is it me or is there a draft
in here?.

3.7L x 3.1D x 8.6H/3.7L x 3.1D x 5.5H

milk £60 cream £32

THE APARTMENT

ToGo

I like it

ToDo
What
Where

Back

Audio

Bathroom

THE APARTMENT

ToGo

ToDo
What
Where

Back

Audio

Magazine trough
Ezri, 2000

Seamlessly hand birch plywood will act as a silent confidant to your unmentionable forays into the world of the published word. It will deliver culture, entertainment, and knowledge, even scandal and smut without judgement. Do as you want.

19"W x 15"L x 16"H

$100

THE APARTMENT

ToGo
ToDo
What
Where

Back
Audio

Simple serving
Craig Varterian, 2000

Made out of tinted wood with stoneware plates, this deceptively simple tray is great for dips, sushi, sauces or keys. Do with it what you will, it won't talk to the cops, even under heavy torture.

163/4"L x 91/8"W x 2"H

$50

THE APARTMENT

ToGo
ToDo
What
Where

I like it

Back
Audio

Caravaggio
Antonio Succoso, 1999

Fresh desserts comfort, a luxury denied it by traditional front holders. With the Caravaggio, a light and flexible mesh container, fresh has once again found its rightful place. With its chromed steel frame and white polyester support bar, it will also fit right in by the tub.

17.7"W x 16.6"H

$120

THE APARTMENT

ToGo
What
Where

I like it

Back
Audio

www.threeoh.com

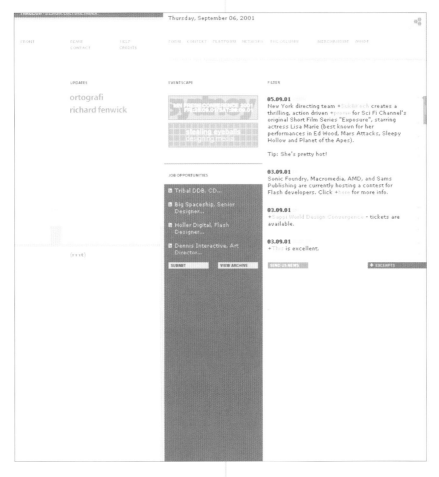

Q1.
What is it about this site (threeoh.com) that makes it different from others?

It used to be different until everybody else started making design portals. But the thing that differentiates THREE.OH from others is filtered quality of exposed inspiration, and highly intelligent editorials.

Q2.
What made you come up with this approach? Inspiration?

It was simply a move from a personal to a more service intended site.

Q3.
If you were president of the World Wide Web what changes would you make?

End the browser war and have one standard.

Q4.
What is your best digital idea or project to date?

The blue THREE.OH, which was a calm and user-friendly experience that presented content effectively and ridiculously fast.

Q5.
Tell us about yourself: age, nationality, interests; anything that makes you different?

I was born in Kalmar on the southeastern coast of Sweden, and eventually studied Media Communication there. After graduating in the end of 1998 I moved to London to work for Razorfish (www.razorfish.co.uk) as a freelance designer. Later on I was given an offer from Vir2L Technology (www.vir2l.com) in Washington DC. I was there for eight months. Then Vir2L opened an office in London where I was working until I resigned in March this year. Now I'm working as a freelance art director moving around. From my first year of studying Media Communication to today I've been running a graphic design portal that goes by the name THREE.OH (www.threeoh.com).

Q6.
List of your favorite web sites and why.

www.iht.com
www.artandculture.com
www.sapient.com

I like these because they are so beautifully executed in all senses. They take advantage of the possiblities, realize them, then present with pride and prudency without fear.

Q7.
What's wrong with most web sites?

They sometimes care too much about the user, and sometimes not enough.

[ɔrtɔgrafi]

Titie	N°11 : Zébulon et son étoile	A side
Date	05/11/2001	
L.A.	Boutet Nathalie	
Music	//	11
Prog	//	

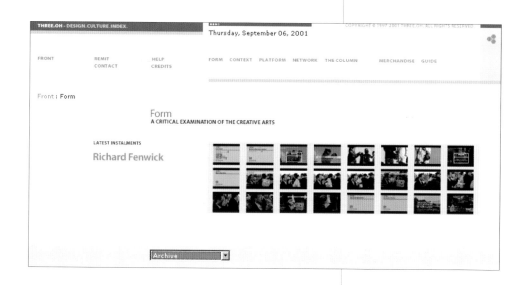

About them:

THREE.OH is a conduit for all those interested in communication arts. Our editorial focus is the relationship between the various creative disciplines and design [in its broadest sense] and furthermore, their relationship to the medium of the World Wide Web.

This site is intended to act as a gateway to the work of other designers, musicians, architects, film — makers and photographers be they or otherwise.

May 1st Reboot - A Reinvigoration of the Web
May 1st Reboot is an international relaunch of web sites by authors and creatives working within the field of Web Design. As a collective event it makes a manifest demonstration of the very idea of community. It is, quite simply, an indeterminate group of designers subscribing to one event in order to publicize their work at one specific time across any number of different locations. And it is in that sense that it is most interesting to us, and by extension to those involved in or entering the world of Web Design on-line. www.threeoh.com/may1

THREE.OH has won twenty-one awards for excellence in web design.

THREE.OH is:
James Widegren - Chief Creative Officer and Founder
Stanley WW - Editor
Bob Ippolito - Code Ninja
John Wier - UI Developer
Aaron Boodman - UI Developer
Mark Sheppard - Web Surgeon
Jens Karlsson - Assistant Creative
Jacob Cohen - Chief Strategist
Patrick Sundqvist - Contributor
Nathan Flood - Contributor
Angel Souto - Contributor
Kim Granlund - Design Technologist

Design, Recognition and Awards

Fierce
www.fierce.com
THREE.OH was the fierce site for May 4, 2001

Media Inspiration
www.mediainspiration.com
Artist of the Month, April 2001

Team Photoshop
www.teamphotoshop.com
Site of the Week, April 2001

Domusweb
www.edidomus.it/domus/
Site of the Week, March 2001

Dazed & Confused Award
www.confused.co.uk
Freeload (favorite web site), issue 71, November 2000

Create Online
www.createonline.co.uk
Recommended site, November 2000

ATTIK
www.attik.com
Won the gallery competition which was hosted by
the ATTIK, September 2000. There were over 200 submissions and three winners.
Contact person:
Simon Mackie-SimonM@Attik.com

Timeout
www.timeout.co.uk
Recommended site by Steve Teruggi, on-line editor
of *Wallpaper* - www.wallpaper.com, 2001

Archinect
www.archinect.com
Cover design, August 2000

Against the Grain
www.againsthegrain.com
Cover design, 2000

Shift Japan
www.shift.jp.org
Cover design, November 1999

Holodeck 73
www.h73.com
Cover design, 1999

Born Magazine
www.bornmag.com
Birthing Room Piece, 1999

The Design Project
www.design-agency.com/project/
On-line gallery for the best Web designers in the World, 1999

Mosquito
www.paregos.se/mosquito/
Won a design competition, 1999

Telia Direkt
www.telia.se/direkt/
Swedish tele communication company — on-line magazine issue design, 1999

Kaliber 10000
www.k10k.net
Designed issue 07 for design portal Kaliber 10000, 1999

www.tomato.co.uk

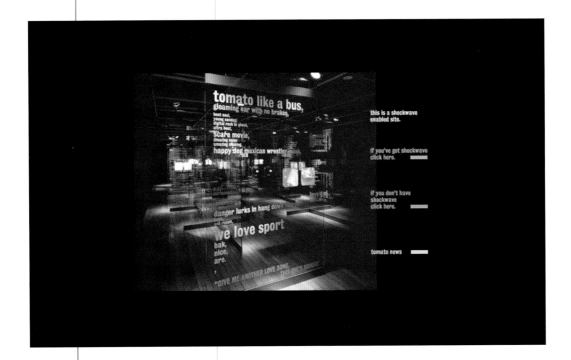

channel 4

strategic document for the brand evolution of the television and web broadcaster, covering all areas of brand culture and identity, in all media.

mmm...skyscraper, i love you

a typographic journal of new york. a tomato/underworld project. published by edward booth-clibborn.

tomato, windows project

as an ongoing project tomato has utilised windows as a frame and a medium to publish ideas and texts. so far the project has occupied spaces in prague, brno, paris and london

promotional brochure

tomato gallery nick parish; one question, so many answers

curated by juanita boxhill, the tomato gallery is used to display projects and installations by tomato and other contemporary artists.

Tomato 03

A self promotional cd that was produced on a business card cd-rom, created to represent the diversity of output from tomato across numerous design disciplines. It is a piece that plays with the representation and navigation around a diverse collection of content.

You can download the Tomato 03 here:

Tomato 03 mini cd. [PC].
Tomato 03 mini cd. [MacOS].

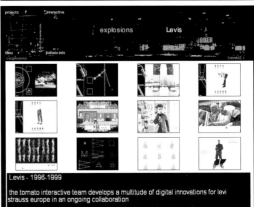

Levis - 1996-1999

the tomato interactive team develops a multitude of digital innovations for levi strauss europe in an ongoing collaboration

< contact school >

tomato, a history

>october 2000

introduction

tomato was founded in 1991 by steve baker, dirk van dooren, karl hyde, richard smith, simon taylor, john warwicker, graham wood and colin vearncombe. jason kedgley joined in 1997 and michael horsham joined in 1998.

karl hyde and richard smith are also 'underworld'.

in 1998 tomato films was formed to produce and represent tomato in both films, documentaries, commercials and videos and is run by jeremy barrett.

also in 1998 tomato interactive was started by tom roope, anthony rogers, joel baumann.

www.toxi.co.uk

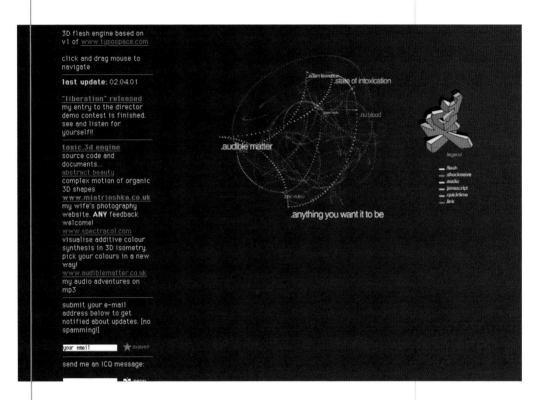

3D flash engine based on
v1 of www.typospace.com

click and drag mouse to
navigate

last update: 02.04.01

"liberation" released
my entry to the director
demo contest is finished.
see and listen for
yourself!!

toxic.3d engine
source code and
documents...
abstract beauty
complex motion of organic
3D shapes
www.miatrioshka.co.uk
my wife's photography
website. **ANY** feedback
welcome!
www.spectracol.com
visualise additive colour
synthesis in 3D isometry.
pick your colours in a new
way!
www.audiblematter.co.uk
my audio adventures on
mp3

submit your e-mail
address below to get
notified about updates. [no
spamming!]

your email ★ SUBMIT

send me an ICQ message:

Q1.
What is it about this site (toxi.co.uk) that makes it different from others?

I hope the content! At least I'm trying hard to come up with material I haven't seen realized on-line before. My other main objective has always been to produce quality rather than quantity. I probably can blame my Dad for this.

Q3.
If you were president of the World Wide Web what changes would you make?

I strongly believe in the freedom of information and no censorship. I'm really getting fed up with just talking about the WWW — the net is the medium and is so much more than just web sites: I met my wife on-line on ICQ. This is not just virtual. All the net's new aspects and means of communication and their social impacts are often forgotten in discussions. The Internet is anarchy and is the biggest social experiment we have ever taken part in (maybe) so we should remember the same when talking about changing the world wide web as part of it. We have now reached a stage where our technology is far more advanced than our social and political behaviors, therefore I wouldn't propose a change in this sense, but release policies which will protect the net's structure as it is at all costs and gives us time to realize the full potential of it...

Q2.
What made you come up with this approach? Inspiration?

Honestly I can't tell really. In general my main inspiration comes from films, pictures, music, books, concepts, and discussions I have with friends I sometimes remember these tiny things and BANG! – Suddenly I'll have this whole cloud of ideas building up around the stimulus. Unfortunately, most of them are lost, because I'm quite a messy person and hardly ever write things down.

But the good ideas seemed to have survived so far...or are still growing. Like for most people, a lot of my projects start off as experiments, when I'm trying out ideas or tools. But the ones I'm really proud of, I usually have finished as big picture in my head before I start developing them on screen. Some parts of my web site are based on ideas I have developed in my mind for years.

Q4.
What is your best digital idea or project to date?

That should be without a doubt www.spectracol.com/. The idea for it had been flying around my head for several months until I programmed and designed the whole thing non-stop in three days last November. From time to time I like to work this hard and looking back, these are the projects I'm most proud of. For me, spectracol is the perfect amalgamation between math, eye candy and an educational tool. The feedback I got from people has been amazing too. On its launch day I had over 2100 hits. Mails I've been receiving from people since are very uplifting — it's good to see that someone's appreciating your work, but for me it's always reason to push myself even further. So I'm back again working on the new version with audio support and more interactive features.

Q5.
Tell us about yourself: age, nationality, interests; anything that makes you different?

25, German, living in London in exile, male, married to a beautiful photographer... I guess I'm a very lucky person, having turned my hobbies into my profession. That also means I do my projects with great passion and this passion is what constantly drives me. My original background is programming when I started as assembler on East German home computers and later on Atari 8bit machines, aged thirteen. Having been part of the whole demo scene of the early 90s, I became more and more interested in extreme graphics (programming), typography and music synthesis and production. Programming on machine level is quite exciting as the machine is doing exactly what you're telling it to do, without any layer between you and the machine. This can create an immense feeling of power. It's like an obsession. So this period has been most influential and I still feel the urge to push myself and the limits of technology I have available. I think that's why I spend a lot of time on optimizing projects, be it code. I'm never completely satisfied with my work. Therefore also my web site is (like it should be) still in progress.

Q6.
List of your favorite web sites and why.

Even though my full-time job is being a web developer, I'm not very much into surfing. But some outstanding sites for me are:

www.k10k.net
Good news items for web folks, I like their humor. The name says all "the designers lunchbox."

www.flashmove.com
Very good discussion boards dealing with everything concerning flash. Source files, tutorials. I am a moderator of one of their boards.

Q7.
What's wrong with most web sites?

Many reasons: the copy & paste mentality. The fact that too many people see the web purely as marketplace now. Too many people hope to make the quick buck, but have no background and knowledge to build successful sites (or businesses on-line) — instead they're looking at already existing sites (i.e. Amazon) or concepts (i.e. portals) and build their version of it — with varying success. One should wonder what all the millions of venture capital is spent on, if not on the products, the web sites. The whole industry seems to be more than happy to deliver average stuff, cash in on it and then masturbate about their self-given awards.

Please, don't get me wrong! I do appreciate straightforward user interfaces and fast-loading web sites. But in the same way I dislike this UseNet mentality I could rant against all these skip intro armies. It's not the tools or technology to blame, it's the people i.e. using flash that should know better about what they're doing. Flash is probably one of the few tools which made design for the web very accessible to a broad range of interested people with all sorts of backgrounds. People who suddenly only needed to master one single tool to build "fantastic" web sites.

It is only recently that we realized the true potential of flash, that it's much more than just mouse trails, flying letters and fading buttons and gradient-shaded vector graphics. We all know what flash can do, when in the right hands — innovation (in computer terms) always major relies on the programming side and with flash 5 we finally have a powerful environment at hand. What we need are educated people who understand the medium and know how and when to use the right tools. I'm glad, macromedia finally realized that it should give out usability guidelines for flash sites to avoid being criticized by UI experts. IMHO, in the near future will separate the good from the average and the bad.

About them:

Awards
"world's best site of the week" award by www.world-3000.com (14/01/2001)

www.triplecode.com

Q1.
What is it about this site (triplecode.com) that makes it different from others?

The site presents different stages of our design process. The structuring of content in an accessible form, "quick" interactive sketches in the "code lab" section, and finished work in the "case studies" section.

We begin every project with an extensive research and exploration phase that aims at finding an unusual core element that captures the client's identity or intent. From there we are able to construct a coherent solution for our projects.

The site's visual simplicity underlines our belief that the core element of a project does not have to be limited to a visual appearance. Instead, it might solely or partly consist of behavioral elements, expressed in movement and interaction, often in strong relationship to the content.

Q2.
What made you come up with this approach? Inspiration?

Interactivity requires as much exploration and sketching as any other aspect of design. It is not a component of graphic design, but an expression in itself. That is why the site includes a lot of active and reactive sketches with little or no traditional graphic design.

Much of the inspiration for the site came about while we were searching for our own identity. We were trying combinations of solid color and abstract shapes, and wanted to see how that could be extended into something dynamic and interactive.

We also wanted the site to demonstrate the type of work we like to do. And so we wanted to be able to have examples of these sketches, experiments and toys on the site.

Q3.
If you were president of the World Wide Web what changes would you make?

We would encourage people to think of the web as a new medium, and not as a digitally adapted version of television or print. It is a medium that offers not only new means, but also encourages us to think about ways to restructure content.

Q4.
What is your best digital idea or project to date?

For Mood Logic we created a Magnet Browser; to let users search for music. It has the tightest connection between data (content) and interaction (design). The dense nature of the information and the medium fit each other very well.

We also like the project we did for Scour, "Project Nile" www.triplecode.com/projects/nile, because it's very dynamic.

Q5.
Tell us about yourself: age, nationality, interests; anything that makes you different?

We think that our combined design and programming approach to projects is unique. For new media, design and programming cannot be separated. We often sketch in code because we believe that content, interactivity, dynamics, and visual design are inseparable.

Both of us (David and Pascal) have strong programming skills.

Pascal is from Germany, David is from Los Angeles (with some family in Australia) and so those backgrounds also influence our work.

Q6.
List of your favorite web sites and why.

Shift.jp.org + k10k provides me with all the latest information happening on the web. Yugo.com for \making me sigh and smile at the same time.

Q7.
What's wrong with most web sites?

They're (1) too static (2) too hierarchical and structured, (3) do not treat their content and design in an integrated way (4) don't author their content to be interactive (5) underestimate their users.

About them:

row2col 3

Awards:
IDSA 2001 IDEA Award
For MoodLogic: Magnet Browser — Gold Medal winner

365: AIGA Annual Design Competition 2001
For MoodLogic: Magnet Browser — in the Experience
Design category

80th Annual Art Directors Club Award (2001)
For MoodLogic: Magnet Browser

2000 Communication Arts Interactive Design Annual 6
For "Scour: Project Nile" web site

2000 New Media Invision Award
Bronze — for "MoodLogic Magnet Browser" web site

1999 New Media Invision Award
Silver — for "2D 3D 4D CD" CD-ROM project

We've also been mentioned, or had our work shown in:
ID, Creative Review, Print, Wired, How, Publish

Key People:
David Young – Partner
David has an MS in Visual Studies from the MIT Media Lab
— where he studied in the Visible Language Workshop with
Muriel Cooper. He also holds a BA in Computer Science from
UC Santa Cruz. He is on the faculty of Art Center College of
Design, and has been involved with the development of their
new media curriculum, and is a former director of their New
Media Research Group.

Pascal Wever – Partner
Pascal graduated from Art Center College of Design specializing
in interactive media. In the Jan/Feb 2001 issue of *Print* magazine
he is listed as one of "30 under 30" — top designers under 30
years old. Previous to his work at Triplecode, he completed
several other award winning interactive projects.

www.typospace.com

05.12.2001

Thanks to everyone who made OFFF such a pleasure. Special thanks to Azu, Héctor and Sergi from the organization team and kudos to the each and everyone we met in this fabulous city of Barcelona. Hope I can come back next year.

Click here to continue

Note: if you don't see an animation in the background of this page click here.

Australia

China

Spain

typospace ::: v.3.in.progress

Milestone 06: Nodes with Submenus

Short-click the nodes to trigger submenus. Click and drag names to change the shape of graphic. Click and drag outside the graphic to rotate. Click and drag center of graphic to move entire graphic. Use up and down arrow-keys to zoom in and out respectively.

Q1.
What is it about this site (typospace.com) that makes it different from others?

You can spin stuff around in three dimensions and you can download the rather complicated Flash source code for free. If that makes a difference it is not up to me but for others to decide.

Q2.
What made you come up with this approach? Inspiration?

Ironically I find most web designers rather uninspiring. Why should I be inspired by something that basically has been established long before the web was even around? Look at Alexandr Rodschenko, Herbert Bayer, Jan Tschichold, Wim Crouwel, Karl Martens, Josef Müller-Brockmann. These guys have laid the ground for us and for most people who are getting their fifteen minutes now and weren't even born yet when the look and feel they are utilizing now was created. I think for inspiration people should look away from web sites and learn from other fields be it classic design, movies, art or science.

On a more contemporary level I would cite the late Muriel Cooper and her students of the MIT Media Lab as a big inspiration. I also admire the Designer's Republic. Their work has been extremely influential as we can see by the fact that numerous "designer" sites are copycatting their look and feel without having the least clue of DR's initial intentions.

Q3.
If you were president of the World Wide Web what changes would you make?

The Web's strongest asset is still its deregulation. It is precisely one of its biggest powers that with some server space, a good idea, and a little knowledge of coding I can put my thoughts out there without anyone telling me how to do that. So this is somewhat a silly question. If I had that power, however, I would immediately shut down any site that carries a "skip intro" button.

About them:

Typospace is not an organization per se. Since it's a one person thing, I am creative director, programmer and designer in one — an ideal state. There is no office. Right now I am personally based in San Francisco, where I work for Method.

Q4.
What is your best digital idea or project to date?

I like the scientific/interactive aspect of typospace. But I am getting a little tired by it and other sites with a more physical/analytical approach towards Flash, such as yugop or praystation.I think my next project, if ever I have time, will be very personal and emotional.

Q5.
Tell us about yourself: age, nationality, interests; anything that makes you different?

At 36 I am certanily considered as rather "old" for this business — at least so it seems whenever there is a gathering of "web personalities" whose average age is way below the 30s. I am originally from Germany which makes me quite anal about certain things — more an advantage than a drawback. I had the privilege of a classic design education in photography and print.
I believe in the basic old principles of harmony, typography, form, function, content and beauty apply across all media — including the web — no matter what anyone might tell you. So the solid old school education often comes in very handy.

Q6.
List of your favorite web sites and why.

I have no favorite sites.

typospace ::: v.3.in.progress Milestone 06: Nodes with Submenus

Short-click the nodes to trigger submenus. Click and drag names to change the shape of graphic. Click and drag outside the graphic to rotate. Click and drag center of graphic to move entire graphic. Use up and down arrow-keys to zoom in and out respectively.

Q7.
What's wrong with most web sites?

Nothing. Again: it's a great medium in which everyone can distribute whatever they feel a need for. Granted, more than often I am annoyed by how much stupidity and bad quality is out there, but in the end looking at the crappy stuff is a small price to pay for the amazing possibilites this thing (still) offers to each and everyone of us.

www.uncontrol.com

Q1.
What is it about this site (uncontrol.com) that makes it different from others?

Uncontrol is neither about making money nor about advertising myself to others. It is a collection of experiments that reproduces motions and behaviors found predominantly in nature. It interprets these motions and behaviors through algorithmic art.

Compared to peer sites like Praystation and Presstube, my site is not that special. Collectively, we are all raising the standard by one upping each other with each experiment that we publish. What makes Uncontrol different to others — I don't know. You have to ask them.

Q2.
What made you come up with this approach? Inspiration?

It's tough to determine a single source or place for inspiration because inspiration happens however, whenever, and wherever it feels like it. Sometimes I'm walking outside or even sleeping when an idea enters my head. I almost have to drop whatever I'm doing and think it through, deciding if it's possible or not; if it's worthwhile to pursue. Once the gears in my head start to settle down a bit, I start sketching. I sketch what it would look like; I sketch the same thing a hundred times, envisioning it from every angle and movement. I even draw out critical snippets of code to make it easier to understand. It also helps to be prepared. I usually have a sketchbook and pencil in every room.

All that said, there are a few things that inspire me on a more regular basis. First, there's TV. I watch a lot of TV. I watch a lot of nature shows like Nova and National Geographic on PBS. All those shows with howler monkeys and termite mounds really have an impact on me. Now I have cable.

Then there are people. When you're working in a vacuum, it's tough to gauge if what you're doing is worthwhile. I work with a bunch of really smart people who can always give me an honest opinion about an experiment or of a design. They also help to work out new ideas, sometime making me gawk at how hard it would be to implement a said idea.

There's also looking closely at simple and well designed objects — like a lighter or even Lego blocks. Breaking down an object to its essential parts allows you to see the object for what it is and what it can do. I choose simple objects because sometimes I end up breaking stuff, trying to see what's inside: complex items are usually more expensive and therefore take a hit in my wallet if I end up breaking them.

Q3.
If you were president of the World Wide Web what changes would you make?

Well, first and foremost I would only allow one browser, which would adhere to all standards. This way, people could spend less time testing and more time creating. Everything would be open-sourced so that anyone could take a peek at the inner workings of html, flash, java and JavaScript, etc. Other than that it would be an incredibly open system; people can do whatever they want, so long as you're not putting kittens in a jar or anything www.bonsaikitten.com. The end result would be a utopian world or complete anarchy. Either way, it would be fun.

Q4.
What is your best digital idea or project to date?

I'd have to say "plotter" is the experiment that I am most proud of. Nico Westerdale, a friend of mine, sat me down and explained the fundamentals of vector mechanics. I took what he said and interpreted it in a Flash piece. Plotter is a script that allows you to control the trajectory of an object by using just three points: a start point, an end point and an offset point. It created a very fluid organic movement found in nature. The flexibility of this code laid the groundwork for many of my recent scripts. By increasing the speed of the transitions, it created a strumming guitar effect (strum). By slowing it down, it created the gentle flutter of a butterfly. By isolating the offset point, it created a jumping behavior (pogo stick). By applying the same script to a series of chained objects it created a fluid moving line (ribbon). By changing just a few variables, the script can be manipulated into a completely different behavior.

Q5.
Tell us about yourself: age, nationality, interests; anything that makes you different?

My full name is Manuel Tan but most people call me Manny. I was born in the Philippines about twenty-five years ago. I like to collect postmodern furniture and sci-fi junk, and I watch 5 hours of TV a day. I currently reside in Queens, NYC. I take the seven train and then transfer to the N train to go to work at Rare Medium, Inc.

About them:

Q6.
List of your favorite web sites and why.

www.safeplaces.net
I like this site because it uses simple elements used to create a highly complex system. There are way too many things to play with here — in a good way.

www.turux.org and www.dextro.org
There are some weird interpretations of movement that are both highly conceptual and naturalistic in this site. With the amount of work evident, it's hard to believe that one person updates this site.

www.homestarrunner.com
Funny as a mofo. The characters are written so well that the episodes almost writethemselves. (Psst. check out Strong Bad Sings.)

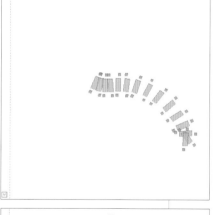

Q7.
What's wrong with most web sites?

I'm probably shooting myself in the foot for saying this, but most sites have little or no good content. There's a fine line between quality and quantity; like a balancing act of sorts. Everyone wants to stay current and to do that you have to update your site frequently. They also want to display only their best work, which usually takes a lot of time and effort to create. More often than not, it seems as though everyone is publishing up anything and everything onto their sites without really filtering the good content from the bad.

317

http://vir2l.com/v3/

Vir2L™
TECHNOLOGY
EMPOWERED BY ZENIMAX

NO FULLSCREEN ENTER ≪ BEGIN
FULLSCREEN ENTER

SITE REQUIREMENTS

NETSCAPE 4.0
INTERNET EXPLORER 4.0
FLASH PLAYER 4.0
QUICKTIME 4.0

24 BIT DISPLAY
800 x 600

SEASONS
OPPORTUNITIES

FEEDBACK

INFO GIFTS LINKS

LINKS

SHIFT

ZENIMAX MEDIA

E-NEXUS STUDIO
BETHESDA SOFTWORKS
XL TRANSLAB

14

SEASONS
OPPORTUNITIES

FEEDBACK

INFO GIFTS LINKS

Company: a ZeniMax Media company
E-mail: dfrederick@vir21.com
Internet: www.vir21.com

http://surface.yugop.com

► **A HAPPY NEW YEAR : INDUSTRIOUS 2001 : YUGO NAKAMURA : MONO*CRAFTS 3.0**

YEAR: **2001**

MONTH: **11**

DAY: **19**

HOUR: **11**

MIN: **13**

SEC: **50**

326

TYPE YOUR KEYBOARD.
THIS STUFF WAS ORIGINALLY CREATED FOR SONY VAIONET100 FEEDBACK INTERFACE STUDY, 2000 SPRING.

DYNAMIC DRAG & THROW : GUESTBOOK
BASED ON RIGID BODY DYNAMICS

► SUBMIT YOUR WORD.

Jackon Chao, Amber Hsu, Katz Lin

Imin Pao, Ivee Hu

please write to us : pao @ paopaws.com

Book designed by Pao&Paws

Cover and insert pages inspired by uncontrol.com

Index